THE
Archive Photographs
SERIES

NEWTOWN
THE SECOND SELECTION

THE
Archive Photographs
SERIES

NEWTOWN
THE SECOND SELECTION

Compiled by
Newtown Local History Group:
Trefor Davies, Betty Griffiths,
Joy Hamer, Brian Johnson,
Brian Jones, Kathleen Jones,
Doug Lloyd, Nixon Oliver,
Ann Owen, David Pugh,
Les Stott, and John Syers

Introduction and captions written by David Pugh

CHALFORD

First published 1998
Copyright © Newtown Local History Group, 1998

The Chalford Publishing Company
St Mary's Mill, Chalford,
Stroud, Gloucestershire, GL6 8NX

ISBN 0 7524 1111 X

Typesetting and origination by
The Chalford Publishing Company
Printed in Great Britain by
Bailey Print, Dursley, Gloucestershire

Contents

Acknowledgements

Newtown Local History Group would like to thank the very many people who have lent us their valuable photographs for inclusion here. Without their generosity, this book would not have been possible.

Once again, we would also like to thank Mrs Kath Thomas, and, latterly, her successors Peter Burt and Mary Young, at the Bell Inn, for allowing us the use of a warm corner of the bar during the preparation of the book.

Introduction

Newtown, despite its name, has existed as a recognised settlement for over seven hundred years. For the first five centuries it remained no more than a small market town of less than a thousand people standing largely within the bend of the River Severn that still encompasses the town's centre.

In the first half of the nineteenth century the town was transformed. Technological advances revolutionised the organisation of the woollen industry and what had for centuries been a dispersed rural activity, carried out in remote agricultural workers' cottages, moved into factories. Newtown became a centre for hand-loom weaving and large buildings were erected to accommodate it. Around the factories workers' cottages were hurriedly put up or, alternatively, a factory was accommodated in large rooms on the top of a row of houses.

The town quickly outgrew its historic site within the arm of the river and in the 1820s a new industrial area was laid out on the north bank in the parish of Llanllwchaiarn. It took its name – Penygloddfa – from one of the fields upon which it was built. At the same time, the Western Branch of the Montgomeryshire Canal Navigation reached the town a few hundred yards to the east of Penygloddfa. This linked the town to the national canal network and provided a catalyst for further development around the wharves of the canal's basin.

Development, albeit to a lesser extent, took place to the south and east along what is now Pool Road and Kerry Road. This culminated in the establishment of the monumental complex erected to house Pryce-Jones's Royal Welsh Warehouse. This business grew from humble origins to be a worldwide distributor of fabrics and garments.

By the beginning of the twentieth century, further advances in textile technology had taken the woollen industry elsewhere and Newtown was in

decline. It was a decline that continued throughout the inter-war period. After the Second World War, however, a determined effort to regenerate the town got under way. The large wartime factory on the Pool Road was taken over by a firm of bicycle manufacturers and hundreds of the poor-quality nineteenth-century cottages were demolished and their inhabitants moved to the new council housing estates at Garth Owen and Maesyrhandir. Nevertheless, by the mid-1960s, it had become clear that this was not enough. The population of Newtown, and indeed the whole of Mid Wales, was still falling. Arresting this decline was clearly beyond the scope of local agencies, so in 1968 the Mid Wales New Town Development Corporation was set up under the New Towns Act of 1965. This resulted in, somewhat confusingly, Newtown New Town being established.

The Corporation's task was to double the population of the town from 5,000 to 10,000. Thus, the town embarked upon its second period of rapid expansion. The 1991 census revealed that the Development Corporation had achieved the objective set out. It was decided that no further major growth should take place, and the town should be sustained at its present extent.

Our first book in the *Archive Photographs* series (Chalford, 1995) concentrated on the town centre. In this second volume we take a closer look at those areas that grew up around the old market town in the periods of development described above. Other sections look at the people of the town, particularly in their non-working hours, through their membership of voluntary organisations, sporting activities, and entertainments.

The last section of the book is a miscellany of photographs kindly lent to us by various people who had seen our first book and thought they had something to offer. While they wouldn't necessarily have fitted in elsewhere, we thought they were too good to leave out.

Newtown Local History Group remains as an informal gathering of people who share an interest in our town's history. While we have done our utmost to ensure the accuracy of the information presented here, experience has shown that errors do occasionally creep in. If you feel that we have got something wrong, or, indeed, you can add to our knowledge of our town's past, or contribute to our work in any way, please contact us: c/o 'Rhoswen', Bryn Street, Newtown, Powys, SY16 2HW.

One
The Parish of
Llanllwchaiarn

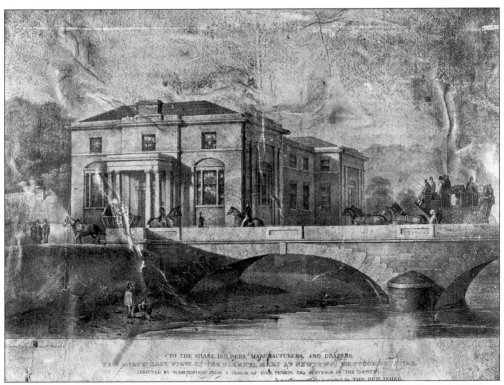

Penygloddfa, across the river from the town centre, was developed in the 1820s and 1830s as the hand-loom woollen industry expanded. To improve communications, the Long Bridge was built *c.* 1827, with the iron footways added in 1857. The newly built Flannel Exchange (now the Regent Centre) is seen here in its original state.

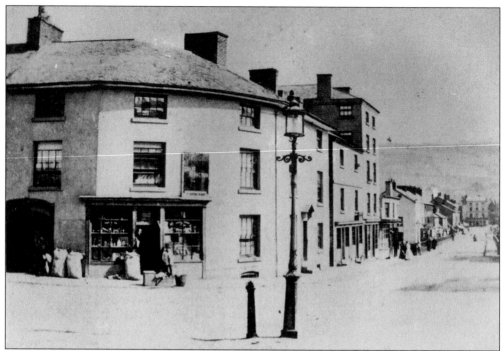

The Long Bridge led into the newly laid-out street pattern of Penygloddfa. The first houses were built behind those in the foreground of this 1890s view. The area took its name from the field in which those houses were built.

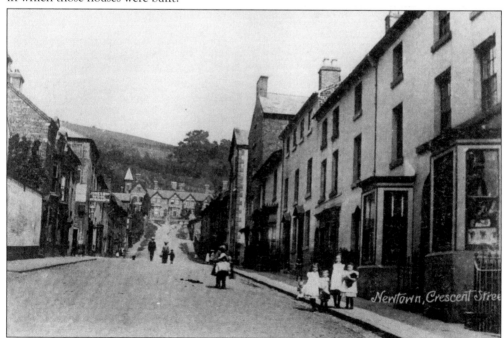

The road from the bridge led through The Crescent to Crescent Street, which has changed remarkably little since this was taken at about the turn of the century. Jones's Wool Warehouse, on the left of the street, burned down in 1938.

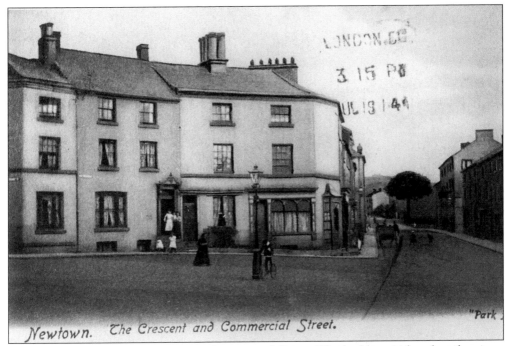

Looking east from The Crescent into Commercial Street. The building with a shop-front was once a pub and is said to be the birthplace of Pryce Lewis who was at one time (but not at the fateful moment!) a bodyguard to Abraham Lincoln. It is now called Lewis House.

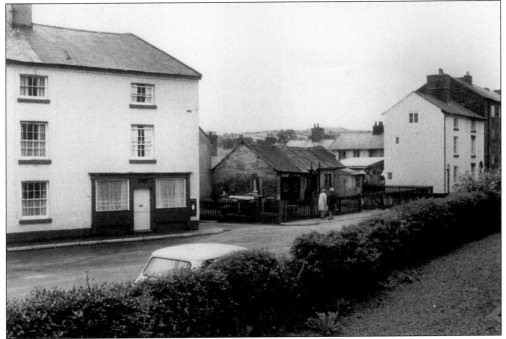

A more recent picture of the other end of Commercial Street, 1960s. The yard and single-storey building houses Morris's monumental masonry business and the shop was at one time Mrs Watt's grocery. It became the lounge bar of the Bell Hotel in 1972. The letter-box remains.

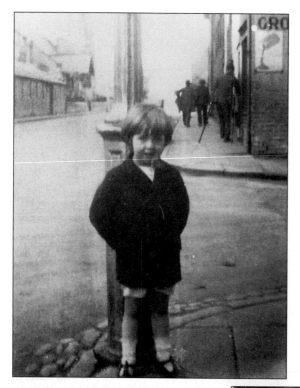

Two snapshots of Commercial Street people. Little Ray Harris stands outside his uncle Martin's butcher's shop in the early 1930s. What is unusual about the picture is that it shows the row of single-storey workshops that once stood next to All Saints' Church. They housed the wheelwrights for Roberts's Commercial Carriage Works next door.

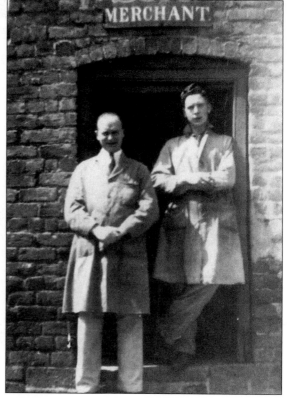

George Jones, the wool merchant, with his son Ivor on the steps of his warehouse in Commercial Street. George's father, also George, had started the business in partnership with his brother Thomas in 1901. Ivor, however, did not follow in the family business and had a distinguished career in the police force.

The New Factory in Union Street, built between 1830 and 1833 by John Matthews, with the 'Truck Shop', latterly occupied by Jack Morris. There were houses on the ground and first floors with the factory above. The building was demolished in 1984 and the site now forms Penygloddfa's only public open space. The original Penygloddfa School can be seen at the end of the street.

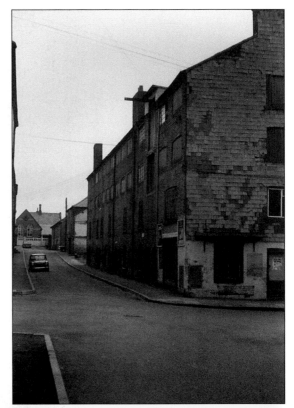

At the height of its development, Penygloddfa must have suffered considerable pollution from all its chimneys. In 1967 there were still enough coal fires in Crescent Street to produce a considerable pall.

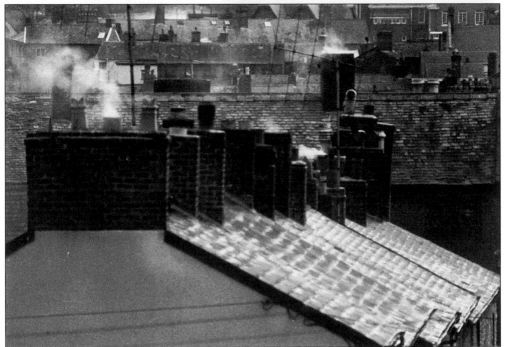

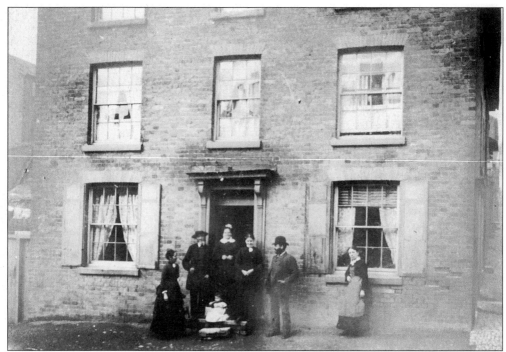

Before the Long Bridge was built, Frankwell Street formed the main road towards Tregynon. Ivy House, which remains largely unchanged at the bottom of Chapel Street, is thought to predate the building of Penygloddfa and may have been a roadside inn.

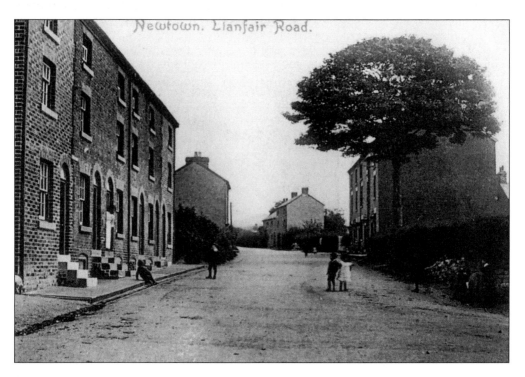

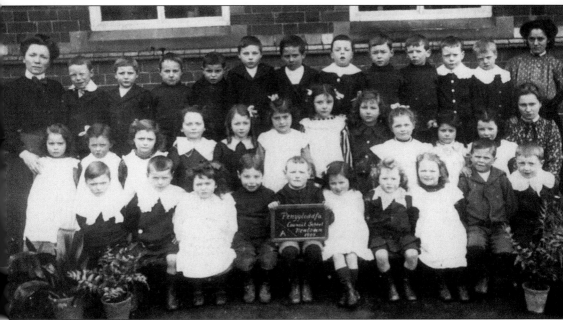

The children of Penygloddfa School in 1909. The school was opened in 1847 as a Nonconformist response to the building of the Church School in Kerry Road that year. As Penygloddfa County Primary School, it remains, somewhat extended, on the same site, although none of the original buildings are still in existence. The Church of England responded to the challenge of a Nonconformist school on the north side of the river by building one of their own nearby. The Llanllwchaiarn National School opened in 1857 in the building now occupied by the Powys Theatre. The school remained in existence until 1933 when its thirteen remaining pupils were transferred to Penygloddfa. Another denominational school was opened in Penygloddfa in 1947. In 1943 a young army officer, Roger Bevan, was sent to Newtown on an anti-aircraft course. He met Father Beddoes, who, the previous year, had become the town's first Roman Catholic priest since the Reformation. They reached an agreement that, if he survived the war, Bevan would open a school to provide a choir for the church Fr Beddoes was planning to create out of the old Syars' Mill by the Long Bridge. Roger Bevan did come back and, with his wife Mollie, he bought Crescent House which had been a sergeants' mess during the war. They opened their school there in 1947, the same year as Fr Beddoes opened his church. A few years later, they were able to move the school to Dolerw Hall, where it remains to this day as St Mary's Roman Catholic School.

Opposite: The bottom of Llanfair Road before it was fully developed. The houses on the left were once eight back-to-backs belonging to the Co-op. They were converted to four normal houses and then an extra one was added to each end to make six in all. The later additions stand out clearly in this picture.

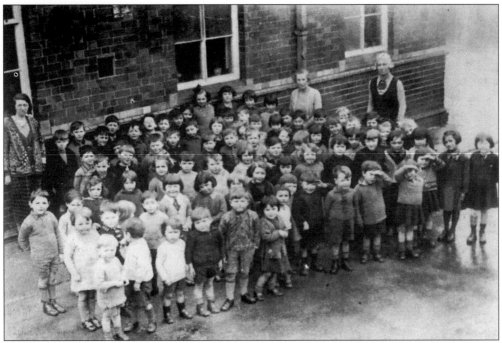

A less formal picture of Penygloddfa's children in 1937, with their teachers, Miss Owen, Miss Shute, and Miss Bryers.

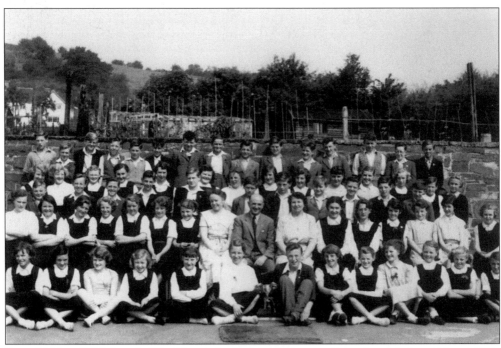

From 1945 to 1957, Pengloddfa School also housed Newtown Secondary Modern School. This picture of the pupils was taken not long before they moved to their new home at the High School.

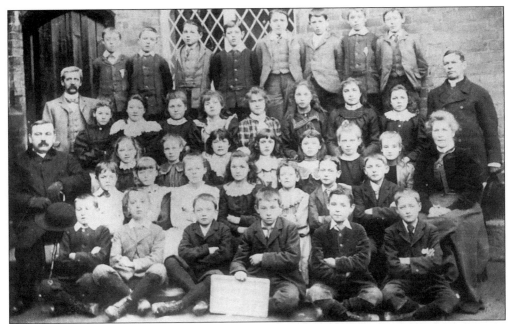

The children of Llanllwchaiarn National School in 1900. The headmaster, top left, was Mr Hodges. Also in the picture are Mrs Hodges, Canon R. Evan Jones, and the curate, Revd Enoch.

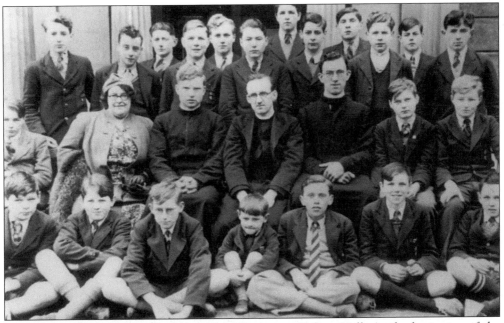

St Mary's was not the first Catholic school to occupy Dolerw Hall. At the beginning of the Second World War, St Anselm's School was evacuated to Newtown from Rock Ferry, Birkenhead. They stayed in Newtown for six months during which time no bombs fell on Merseyside so they returned. By the time the bombing started, Dolerw had become the officers' mess of the army unit that had come to the town, so the school could not return. The picture shows the boys and teachers of St Anselm's outside the front door of Dolerw.

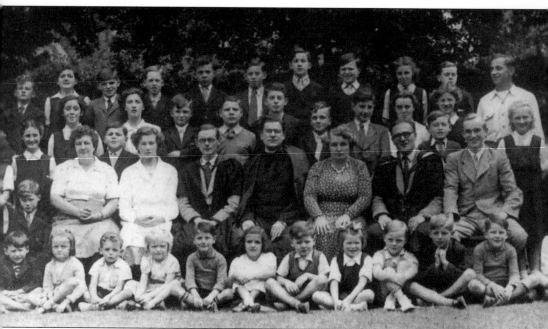

The pupils of St Mary's, *c.* 1950, with their headmaster, Roger Bevan, and Father Beddoes.

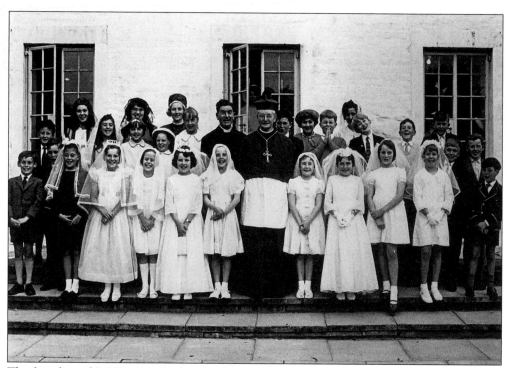

The founding of St Mary's took place in the same year as the consecration of the new Catholic Church in the old Syars' Mill. Here Father Beddoes and the bishop join newly confirmed children outside the crypt of the church.

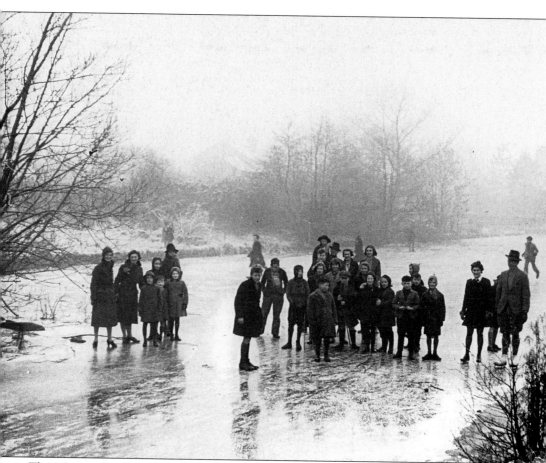

The Montgomeryshire Canal (Western Branch) reached Newtown in 1821. Subsequently, a community grew up around its terminal basin. Factories, shops, pubs, and houses were built and many of these buildings remain. With the coming of the railway, the canal gradually fell into disuse. However, the waterway was not formally abandoned for navigational use until 1944, although it had been many years since boats had regularly visited Newtown, particularly after it was cut off from the national network by the collapse of an embankment near Welsh Frankton in 1936. A number of proposals to use the old canal for recreational purposes came to nothing but, as shown here, the bitterly cold winter of 1940 did convert the canal basin into an excellent skating rink. Only Leslie Breese (in the trilby hat on the right of the picture) of Redcot, and his wife Mary (next to him), seem to have actually had skates, however.

By 1881 there were 346 people living around the canal basin. Most of their houses have gone, but these four remain. This picture was taken when the end of the First World War was being celebrated. The little boy with the dog (or is it a pig?) in the nearest doorway had particular reason to celebrate. He is Ernie Bauer and his father had been interned as an enemy alien. Heinrich Bauer had come to the town about twenty years earlier and had married a local girl. But this, and the fact that his eldest son was serving in the British army, carried no weight with the authorities.

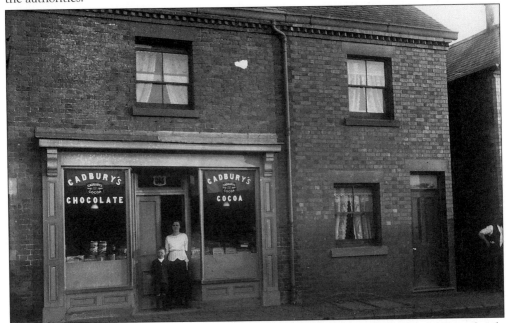

A little further along the Basin stood this shop. For many years it was run by the Rees family and later by the Hedges. It eventually became the Canal Road branch of the Newtown Co-operative Society. It is now a private house.

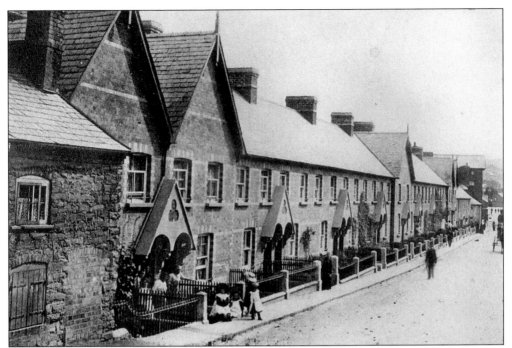

Two views of the fine Victorian houses that comprise Dysart Terrace. They were built in 1875 by Charles Hanbury-Tracey (later Lord Sudeley) to house workers at the adjacent Commercial Mill. They were named after Hon. Hanbury-Tracey's father-in-law, Lord Dysart. These pictures, probably taken at about the turn of the century, show how little the terrace has changed in nearly a hundred years.

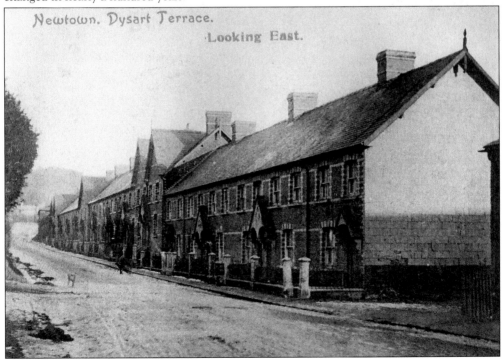

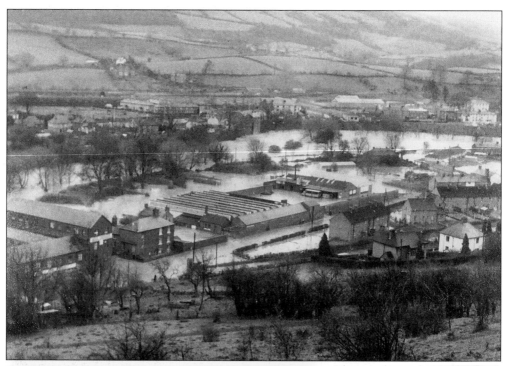

The canal area during the flood of December 1960. It shows the line of the canal behind the old Commercial Mill buildings, past the Central Dairy and under the bridge whose parapets can be seen on the right of the picture. Between the canal and the river are mounds which were the remains of the twenty-two lime kilns served by the canal boats.

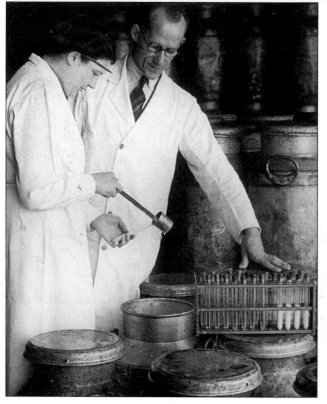

Before the days of bulk collection, milk was placed in churns by the farmers, put on roadside stands, and transported to the dairy. There it was tested for butterfat content (as shown in this picture), pasteurised, and either bottled or put back in churns for distribution. Local milkmen had ponies and traps from which they sold the milk directly from the churn.

During the Second World War the Birmingham factory of Price Bros (Tools) Ltd was destroyed by enemy bombs and work was transferred to the old Commercial Mill buildings. At that time Price Bros were engaged in munitions work. After the war, they turned their efforts to domestic electrical equipment as seen in this advertisement.

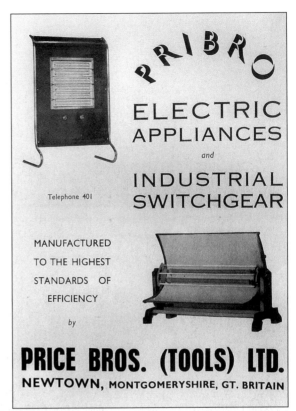

Telephone 401

PRIBRO

ELECTRIC APPLIANCES

and

INDUSTRIAL SWITCHGEAR

MANUFACTURED TO THE HIGHEST STANDARDS OF EFFICIENCY

by

In 1951 the firm became Price & Orphin and concentrated on precision engineering. Amongst other things, they machined parts for aircraft and racing cars. This picture shows their apprentices' training school in 1974.

PRICE BROS. (TOOLS) LTD.

NEWTOWN, MONTGOMERYSHIRE, GT. BRITAIN

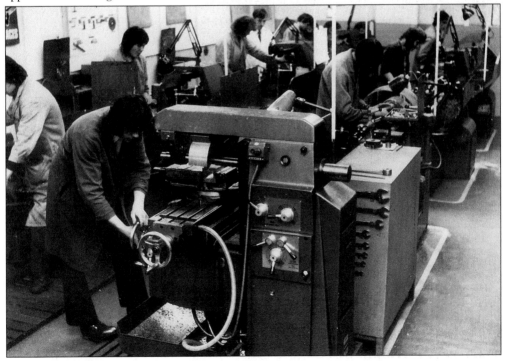

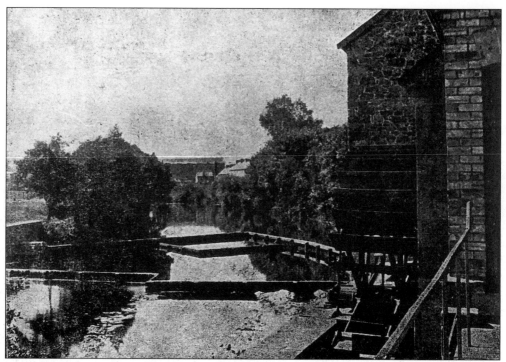

Water was fed into the head of the canal from the river by means of a pump driven by the 22ft water-wheel shown here. About 1860 a stand-by steam engine was installed. The water-wheel remained in use until 1924 when both it and the steam engine were replaced by diesel-fuelled machinery. Pumping ceased altogether soon after the nationalisation of the waterways in 1948.

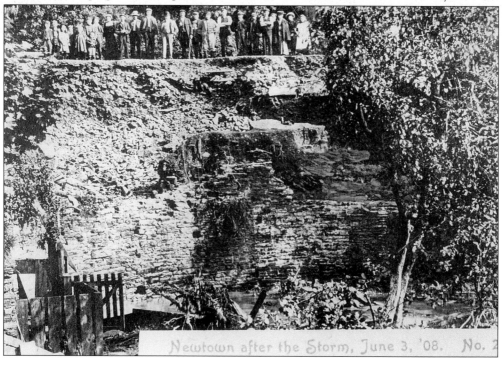

Newtown after the Storm, June 3, '08. No. 2

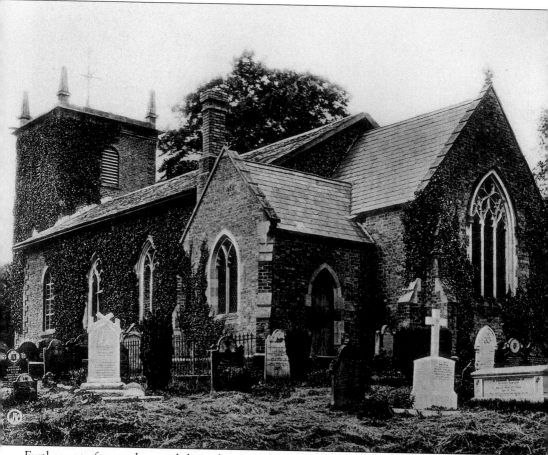

Further out of town the canal skirts the yard of the Parish Church of St Llwchaiarn. Since this picture was taken *c.* 1900, the yew trees have grown to almost obscure the building.

Opposite: The canal was also fed by the waters of the Pyllaubudron brook which ran into it at the Pump House. The brook entered the canal by way of a culvert, which has never been a successful piece of civil engineering, under the Canal Road. In storms, it has a tendency to get blocked, causing flooding or, as shown here in 1908, making the roadway collapse into the canal.

Near the church, the canal is bridged by the road to The Rock. This bridge remains here but the canal was drained in 1971 to make way for the town's new outfall sewer which was laid in the bed of the waterway from the basin to the sewage farm.

VIEW ON CANAL ABERBECHAN NEWTOWN.

No boat has been able to travel the canal for many years but lower down much work has been done on reopening it for general use. How close the restored canal will come to Newtown remains to be seen.

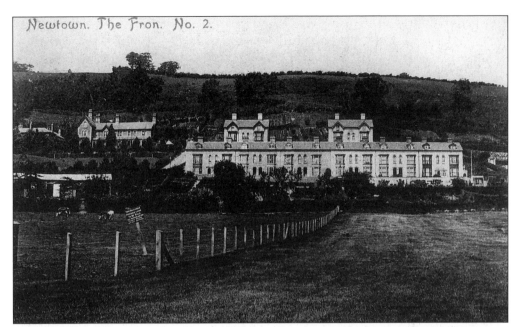

Without the canal as a catalyst, development to the west, on the north side of the river, was much slower. Apart from the old mill at Milford and Lee's Brickworks up Llwynon Lane, there was no industry. Consequently, it became the area where the more affluent people of the town chose to build their houses. This c. 1905 view shows Penygraig Field and Tradyddan Terrace from the Milford Road. The sign proclaims that Francis Knapp was offering the field for sale. Mr Knapp was at one time head brewer at the Eagles Brewery.

Next to Penygraig Field stands the Welsh Congregational Chapel, built in 1865 on land given by Lord Sudeley. This picture shows the building before it was renovated and altered in 1909.

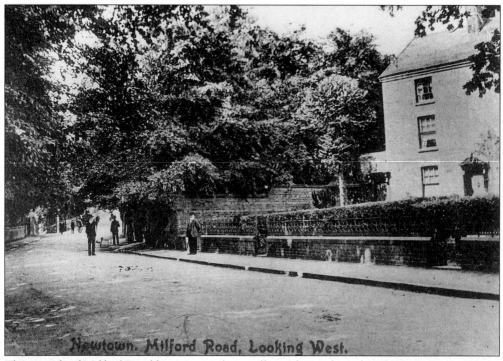

Newtown. Milford Road, Looking West.

This stretch of Milford Road has remained virtually unchanged in a hundred years

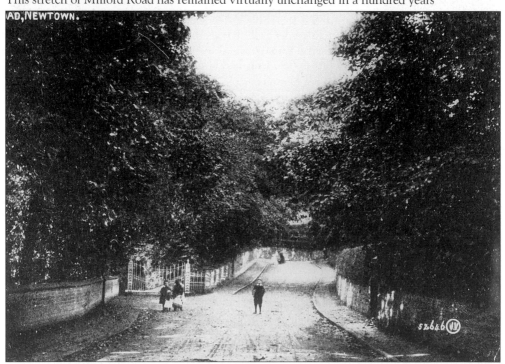

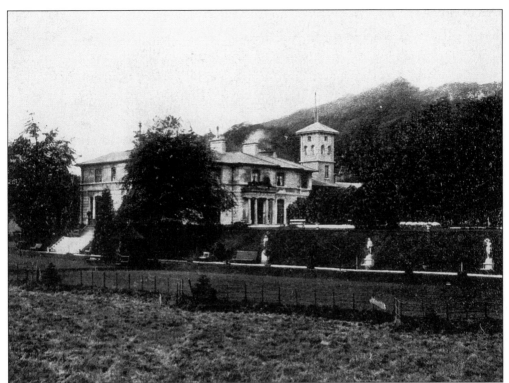

Dolerw Hall was built, probably in the 1820s, on part of what was Dolerw Farm. Having housed two of the town's wealthy doctors, Lutener and Slyman, it became the residence of the Pryce-Jones family in the 1880s. At that time it was enlarged and took on the form shown in these two pictures. In 1949, Sir Victor Pryce-Jones, who had already left the town, sold it to Father Beddoes to accommodate St Mary's Roman Catholic School.

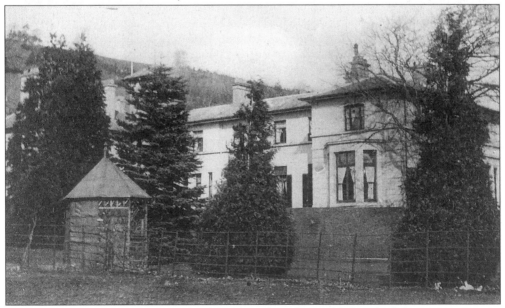

Dolerw Hall from the west. New school buildings have been added to the left.

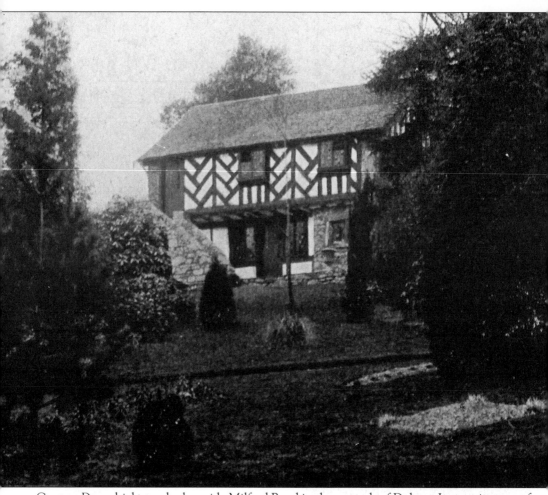

Cwrt yn Dre, which stands alongside Milford Road in the grounds of Dolerw. It contains part of a house that originally stood in the centre of Dolgellau. Contrary to popular legend, it has no connection with Owain Glyn Dŵr, but was built in the sixteenth century as the home of Lewis Owen, Baron of the Exchequer for North Wales, who was killed by the Gwillad Cochion (the Red Bandits of Mawddwy) in 1555, on his way home from the Montgomeryshire Assizes. In 1885 the banqueting hall of the house was bought by Mr (later Sir Pryce) Pryce Jones. It was dismantled, loaded into a special train of 32 wagons and brought to Newtown, carted to Dolerw where it was recreated under the supervision of the architect A.B. Phipson. In the event very little of the original material was used in the reconstruction. Sir Victor Pryce-Jones, the last of the family to live at Dolerw left Newtown in 1939 to live at Great Ryburgh in Norfolk, where he remained with his wife, Lady Syra, until he died in 1963. During the Second World War the army occupied Dolerw and Cwrt yn Dre fell into disrepair. In 1956, at the suggestion of Miss Medina Lewis of Milford Hall, Sir Victor granted the Guides permission to use the building rent-free. It was put in good order by local volunteers, including the Boys' Brigade. Twelve years later the building had another change of occupier as in October 1968 Lady Syra Pryce-Jones re-opened Cwrt yn Dre as the Friends Meeting House, which it remains to this day.

Until the inter-war years the built-up area of the town ended at Dolerw Farm. This picture shows the entrance to The Common before development began.

Not a memorial to a departed amphibian but the milestone that stood where the entrance to Bod Ifan now is. When the new roadway was created, it was moved a few yards to the west. The last mile is a little longer than it used to be.

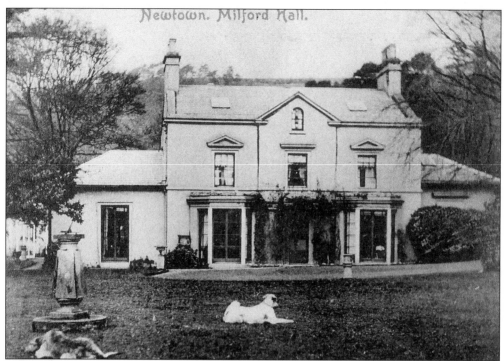

Just beyond the milestone stands Milford Hall, a Georgian country house dating from *c.* 1800. For many years it has been the home of the Lewis family.

About three hundred yards beyond Milford Hall stood St David's, the home of Mr Arthur W. Pryce-Jones, more usually known as 'Mr Bertie' to distinguish him from his brother Edward – 'Mr Ernest'. In December 1906 the house burned to the ground in a disastrous fire. Although it was rebuilt in a very similar style, Mr Pryce-Jones never returned to it. He moved first to Caersws, then Canada, and finally Brazil.

Two

Pool Road and Kerry Road

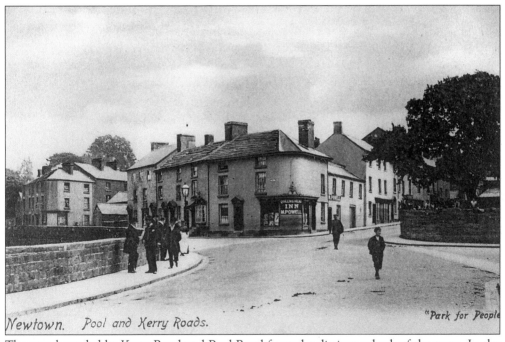

Newtown. Pool and Kerry Roads.

"Park for People

The area bounded by Kerry Road and Pool Road formed a distinct suburb of the town. In the early years of this century it was said to be possible to distinguish between people who lived here and those from other parts of the town by their accent. At the meeting of the two roads stands the Queen's Head Hotel, the only building in this picture that remains.

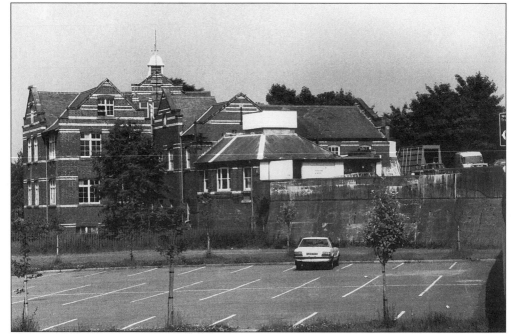

Pryce-Jones Laundry in 1988. The building was demolished in 1993. It had been used not just as the town's laundry but a finishing plant for the garments made in the Pryce-Jones factory on Kerry Road. It also served as a power station, generating electricity to drive the machinery in the factory. The current was carried in a heavy cable that ran along the wall on the right of the picture and thence underground up Kerry Road.

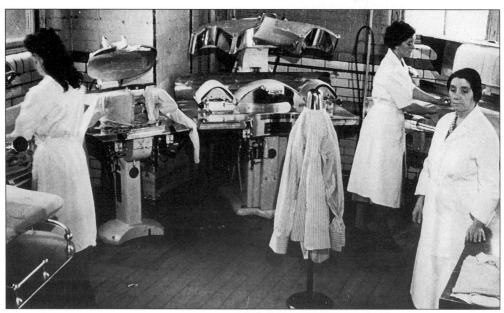

These ladies are seen operating the new shirt-finishing machinery installed in the laundry in 1950.

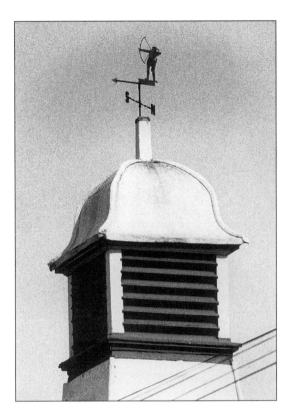

The Laundry building was surmounted by two ventilators. On each of these was a weather vane, one depicting a bowman, the other a prancing horse. What significance, if any, these had is not known.

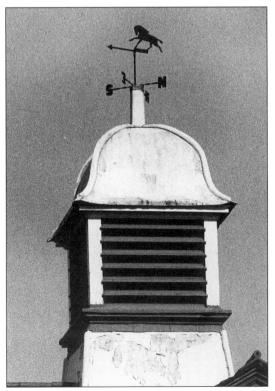

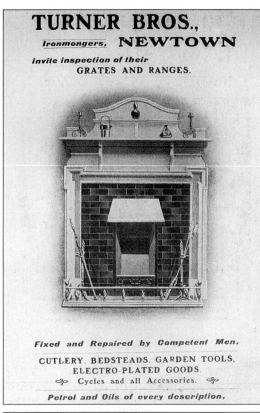

Next to the Laundry stood Turner Brothers' Cambrian Foundry. This made all manner of ironwork, domestic ironmongery for their shop in Market Street, and a wide range of industrial and agricultural machinery.

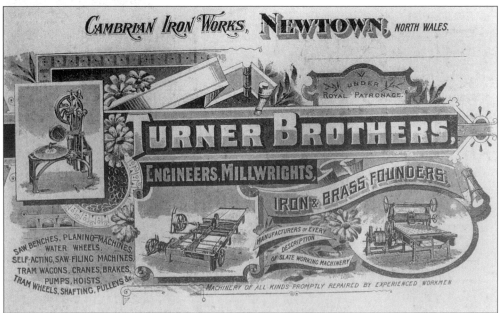

At one time the most important aspect of the foundry's business was the manufacture of machinery for the slate industry. The original Cambrian Foundry was demolished to make way for the new Cambrian Bridge and the business was moved to the Dyffryn Estate, where it remains.

Pool Road looking towards the town. The large house in the distance once housed a school. It, along with most of the other buildings in the picture, has gone. The Wheatsheaf Inn, boarded up on the left in this picture, remains.

Pool Road looking away from the town from just beyond the lamppost on the right of the picture at the top of this page. The Wheatsheaf looks in better shape here.

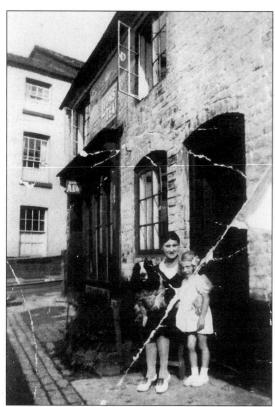

Opposite the laundry, at the bottom of Stone Street stood this little shop. It had served a number of purposes – as a barber's and a shoe shop – but Miss Annie Evans ran it as a grocer's. Her cousin Elsie Nicklin, niece Ann Davies, and dog Duke sit outside.

Richard Groom opened his garage on Pool Road after the First World War. After the Second World War it was taken over by Edward Morris Jones who decided to concentrate on the wholesale trade – a business which became Groom's Industries. The original garage passed to the Cakebread family who still operate a filling station and sell cars on this site.

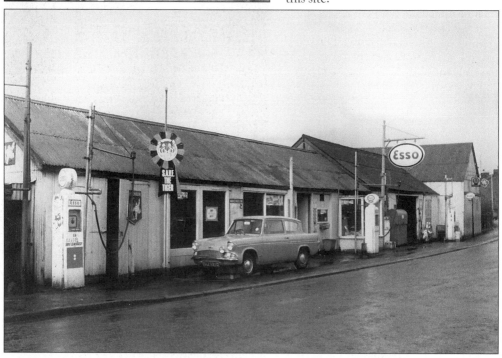

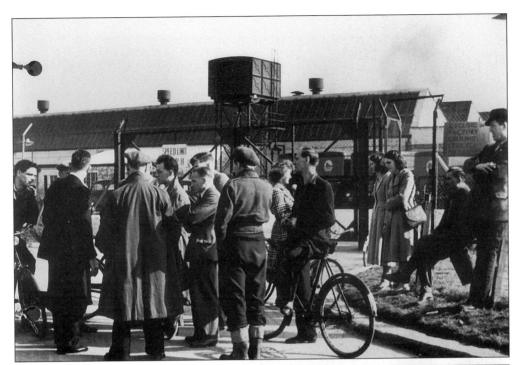

The Pool Road factory was built for Accles & Pollock's in 1942 under conditions of great wartime secrecy; it manufactured aircraft parts. After the war the factory passed to Messrs J.A. Phillips for the manufacture of bicycles. Industrial relations were not always smooth and this picture was taken during a strike in 1952.

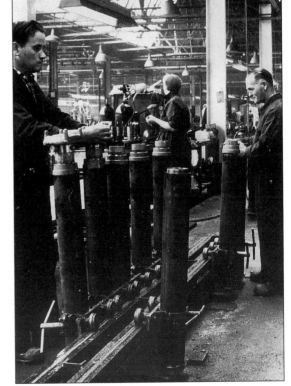

Overseas competition led to the closure of Phillips's in 1958 and the factory was taken over by Brampton Fittings. In 1961 the factory changed hands again, this time to BRD Ltd of Aldridge, Birmingham and Floform Ltd, both part of the GKN Group. This picture shows BRD workers in the factory making propeller shafts for the motor industry.

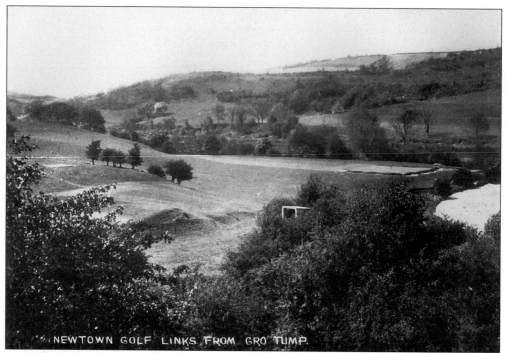

NEWTOWN GOLF LINKS FROM GRO TUMP.

As well as industry, Pool Road gives access to two major sports facilities – the Recreation Ground, and St Giles Golf Club beyond it. This is part of the golf course seen from the Gro Tump *c.* 1928, before the present first green was constructed.

For those who wished to take a walk without the aid of a club and a ball, the Gro Bridge (usually called the Parson's Bridge, after its predecessor) allowed one to stroll from the town on one side of the river and return on the other. It was carried away in a flood in 1946 and, although it was insured, it was never replaced.

This building which until recently stood in Mochdre had its origins on the Recreation Ground. Towards the end of 1902 there was an outbreak of smallpox in the town. There was an urgent need for an isolation hospital so the Town Council contracted Jones Bros, the ironmongers, to put up a temporary building on the RWW cricket ground. By the time it was ready the outbreak had ended so it was never used. In May 1903 the RWW Recreation Society wrote to the Town Council asking them to get their hospital off the cricket pitch as the RWW had an important match to play at the end of the month. The Council, not surprisingly, had some difficulty in finding a new home for it, but eventually they were able to buy a piece of land in Mochdre from Richard Lloyd, Mochdre Mill. The 'important match' was not played on the Rec that May, however, as the Council was not able to start moving the hospital until June. Once on its new site, it was kept in readiness should there be another urgent need for an isolation hospital. It remained in Mochdre for over ninety years – an unusually long life for a temporary building.

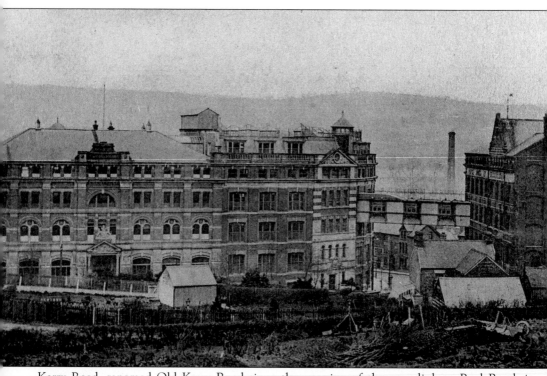

Kerry Road, renamed Old Kerry Road since the opening of the new link to Pool Road, is dominated by the massive bulk of the Pryce-Jones buildings. This complex was erected in three stages: the original Royal Welsh Warehouse, comprising the seven bays on the left of the picture, was opened in 1879; next, in 1895, came the building on the right, now known as Agriculture House, with a smaller factory belonging to Pryce-Jones demolished to make way for it; in 1901 work began on the extension towards Kerry Road of the original warehouse and when it was completed in 1904, a bridge was erected over Station Approach to link the two blocks. The complex was used for the manufacture and sale by mail order of woollen articles and garments. Pryce-Jones's Welsh flannel became famous throughout the world and was worn by most of the crowned heads of Europe. During the depression of the inter-war period the business declined, however, and in 1938 it was taken over by Lewis's who opened a department store in the original building. During the Second World War the 1895 factory became an Admiralty victualling depot. After the war various civil service departments took over from the Admiralty and the building was re-named 'Agriculture House'. As there was no longer a need for a link between the two blocks, the bridge was removed in 1951. Garment manufacture at Pryce-Jones's ended in 1970 with the closure of Universal Shirt Products. A large part of the building is still used for the retail business and it also retains a close link with its original purpose, housing as it does the regional office of Kays of Worcester.

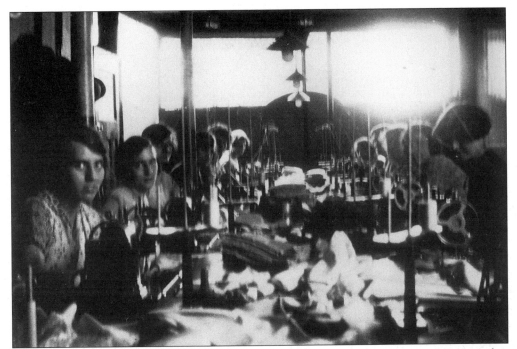

A rare, but rather shaky, picture of women working in Pryce-Jones Factory, c. 1917. Note that their workplace is lit by electricity from the laundry. Mains electricity did not arrive in the town until 1933.

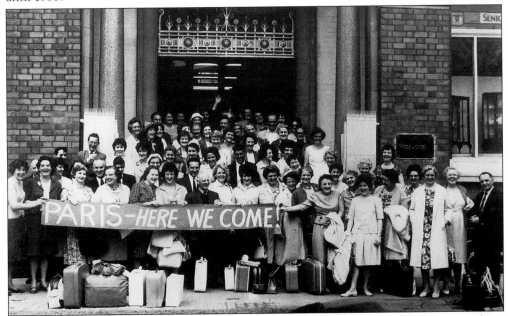

PARIS – HERE WE COME!

From its earliest days Pryce-Jones's had a tradition of providing social activities for its workers. Behind the warehouse there was a bowling green and tennis courts. There were also the usual 'works outings'. In the 1960s they became a bit more adventurous and a number of foreign trips were undertaken. The first of these was a weekend in Paris in June 1963. For many it was their first trip abroad and a big occasion for all concerned.

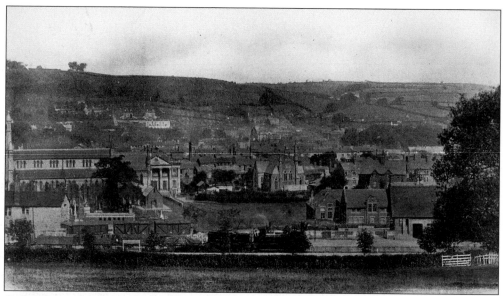

A Cambrian Railways goods train pulls into Newtown station before the Cambrian was amalgamated with the GWR in 1922.

To the west of the passenger station was the railway goods yard, part of which can be seen here. Beyond it is the abandoned Severn Valley Mill.

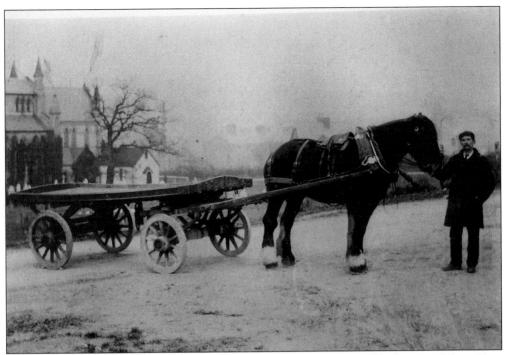

Until the 1950s many of the goods brought to the town were delivered by horse and dray. Here a drayman and his horse pose for the camera in the goods yard.

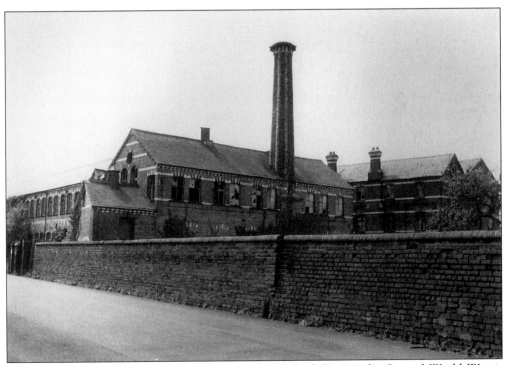

The Severn Valley Mill shortly before it was demolished. During the Second World War it served as a barracks, first for the Royal Irish Fusiliers, and later for the Royal Artillery.

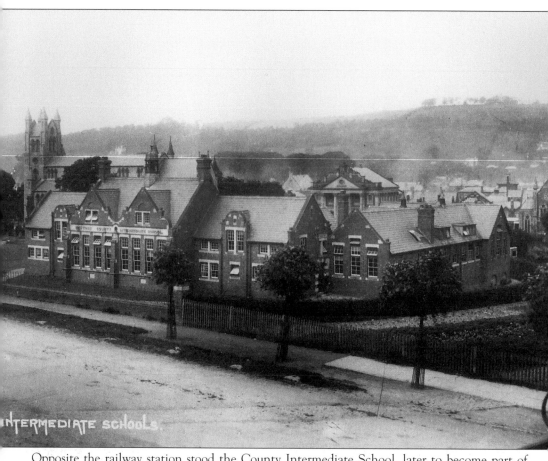

Opposite the railway station stood the County Intermediate School, later to become part of Montgomery College of Education. These buildings were demolished to make way for a supermarket.

Three
Youth and Voluntary Organisations

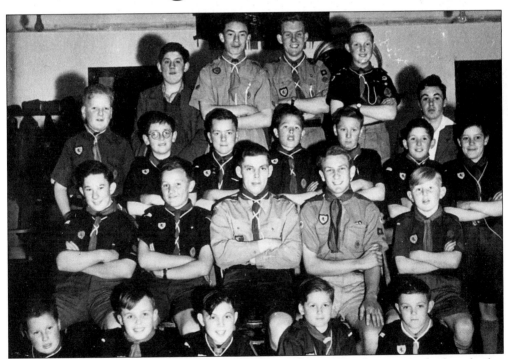

Newtown has had a scout troop for almost ninety years. Here they are with their leader, Edmund Davies, c. 1954. From left to right, back row: William Blayney, Roger Mellings, David Powell, Ivor Breeze, Eric Jones. Third row: Geoff Jones, John Syers, John Owen, Gary Ramsey, Leslie Williams, John Smout, Terry Attwood. Second row: Donald Davies, Gerald Humphreys, Edmund Davies, Ivor Rowlands, Alan Sefton. Front row: David Williams, Barry Baynham, Brian Breeze, -?-, David Owen.

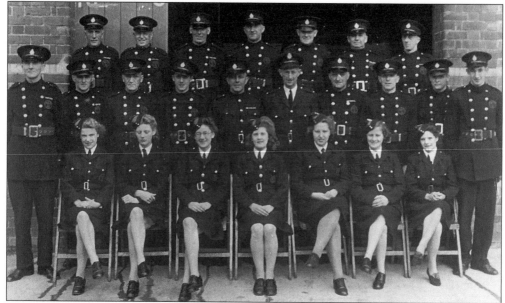

During the Second World War Newtown Fire Brigade became part of the National Fire Service and, for the first time, women were admitted to the ranks. Pictured here in 1944 outside their temporary fire station in Newtown Motor Garage on Pool Road are, from left to right, back row: Tommy Evans, Steve Snead, Charles Davies, Fred Humphreys, Bill Thomas, Seymour Davies, Bert Davies. Middle row: J. Peter Jones, Bill Pryce, Sid Williams, Ivor Gittins, Albert Powell, Company Officer Barrodale, George Williams, Fred Williams, Cliff Thorne, -?-. Front row: Violet Owen, June Harris, Rhona Williams, Gaynor Evans, Elsie Williams, May Jones, Beattie Rogers.

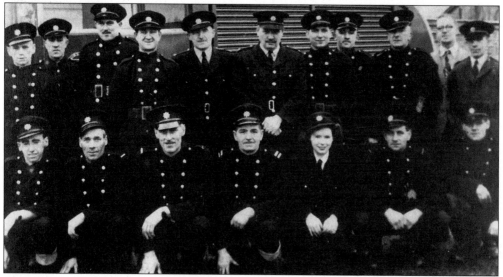

After the war the brigade returned to local authority control. Here they are in 1952 in front of their new fire engine. From left to right, back row: FM Syers, FM Blayney, FM Gittins, FM Morris, SO Humphreys, SO Rowlands, FM Underhill, FM Owen, FM Blayney, L/FM Wilson, FM Kendall. Front row: FM Jones, L/FM Evans, L/FM Roberts, SO Lynch, FW Harris, L/FM Williams, FM Owen.

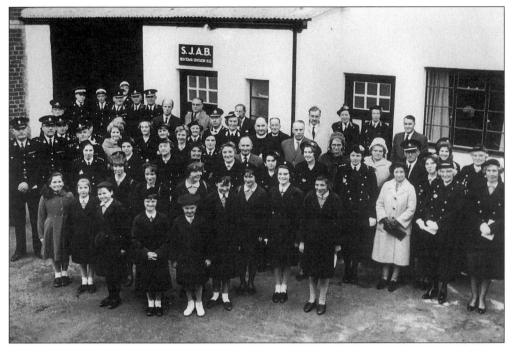

Until 1970 the town's ambulance service was run voluntarily by the St John Ambulance Brigade. After the formation of a full-time service, brigade members continued to provide a valuable service for local events. Here the members stand outside their new headquarters on New Road after its official opening by Lady Davies in 1963.

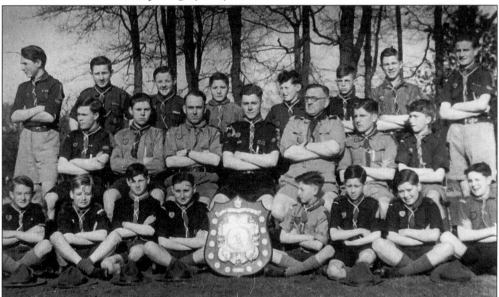

Newtown Scouts, pictured in June 1947 when they were winners of the County Shield. From left to right, back row: L. Thomas, J. Jones, K. Jenkins, S. Owen, R. Swain. Middle row: T. Powell, E. Davies, D.L. Jones, J. Woodhouse, Revd J. Sinnett Richards, C. Oliver, P. Edwards. Front row: T. Davies, S. Wilson, N. Smout, C. Rees, A. Breeze, M. Watson, J. Hughes, L. Evans.

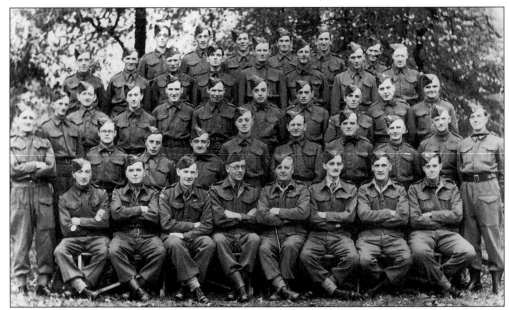

Following a broadcast appeal by Secretary of War Anthony Eden in May 1940, fifty-two Newtown men presented themselves at the police station to join the Local Defence Volunteers, later to become the Home Guard. Here they are in 1942 with their commander, Major Gwilym Rees. From left to right, back row: Raymond Jones, E. Jones, E. Jones, J. Meddins, E. Jones, E. Mills. Fourth row: A. James, R. Davies, D. Morris, -?-, C. Whitticase, F. Jones, -?-, J. Jones. Third row: J. Birch, P. Humphreys, J. Jones, George Colley, Harold Bennett, R.E. Edwards. Second row: R. Williams, W. Williams, S. Jones, -?-, E. Pugh, B. Griffiths, -?-, D. Edwards, ? Piercy, C. Owen, R.B. Jones. Front row: E. Blayney, George Jones, ? Horton, Griff Jones, Gwilym Rees, J. Thomas, W. Evans, E. Hanson.

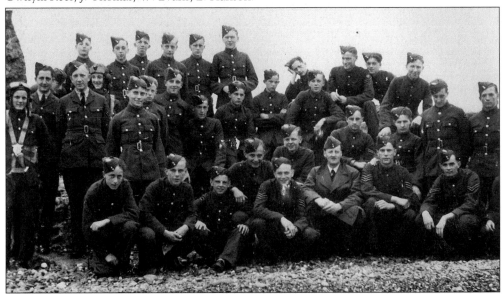

Newtown Air Training Corps was founded in December 1941 by two County School teachers, Mr Beverstock and Mr Roderick. In March 1942 they were officially recognised as Unit 1907. This picture shows them at camp at Towyn in August 1942.

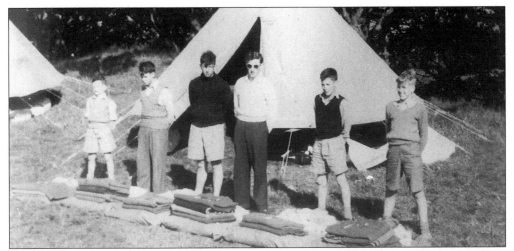

The 1st Newtown Company of the Boys' Brigade was formed in December 1951 with Mr B.G. Burrows as captain. In the August 1956 they held their first camp at Rhowniar near Aberdyfi. Here Alan Williams, Roy Morris, David Pugh, David Rees, Meirion Roberts, and Andrew Griffiths have their kit ready for morning inspection.

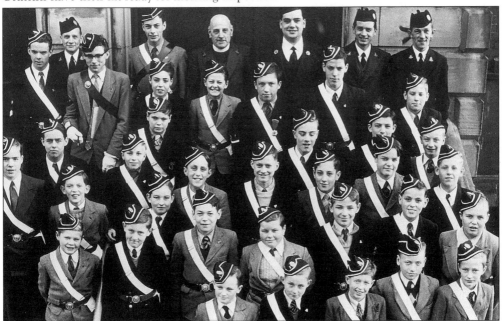

In the autumn of 1956 the 1st Newtown Company held their annual enrolment at the Methodist Chapel. They had their photograph taken on the steps of the chapel afterwards. From left to right, from the back: Mr Burrows, D.J. Williams, Revd D.T. Rees, Mr Michael Davies, Mr Idris Owen, Mr Walter Bunney, Tony Moss Davies, Tony Brunning, Richard Morris, Michael Bayley, David Pugh, Lynn Jones, Roger Jones, Graham Lewis, Trevor Clark, -?-, Lyndon Clark, Roy Morris, Jon Pickett, Melvyn Young, Michael Morgan, Meirion Roberts, Neil Pickett, Andrew Griffiths, David Lewis, ? Ellison, David Percival, Reynell Morris, Roy Haynes, Bobby Davey, Roger Brunning, Robert Jones, Barry Baynham, Alan Williams, -?-, D. Owen, Edward Logue, John Freer. The Boys' Brigade held their weekly meetings in the schoolroom beneath the Methodist Church.

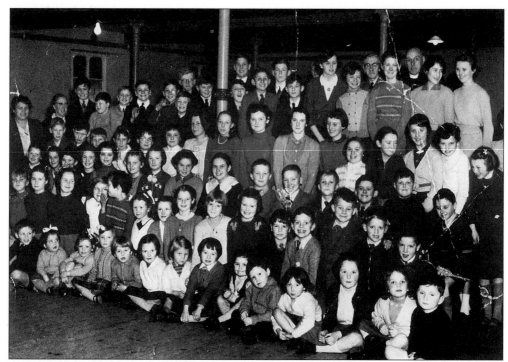

The Methodist Church's own children had activities in the schoolroom as well, as seen here, c. 1957.

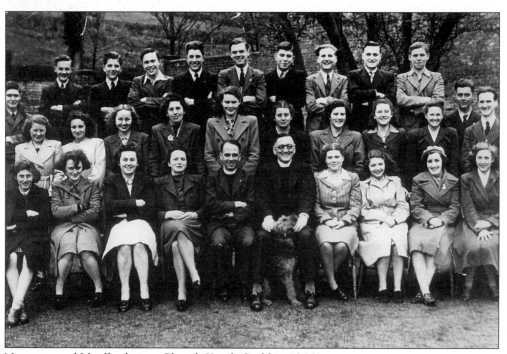

Newtown and Llanllwchaiarn Church Youth Guild in 1946.

Four
Entertainment

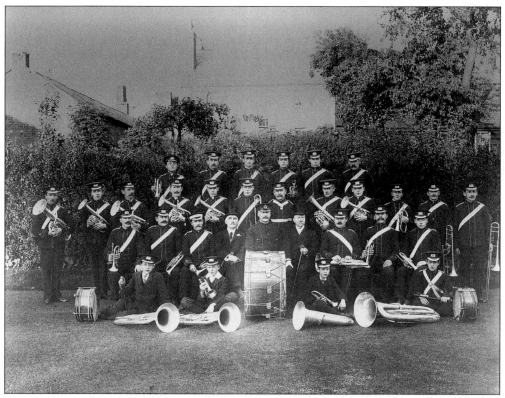

Despite the coming of the electronic age the town continues to provide its own musical and dramatic entertainment. Probably the oldest musical organisation still in existence is Newtown Silver Band. The band was formed in 1880 'for the pleasure and edification of the inhabitants' as Newtown Brass and Reed Band. By 1888, the date of this picture, the woodwind players had exchanged their reeds for brass and the name was changed to Newtown Silver Band, and so it remains.

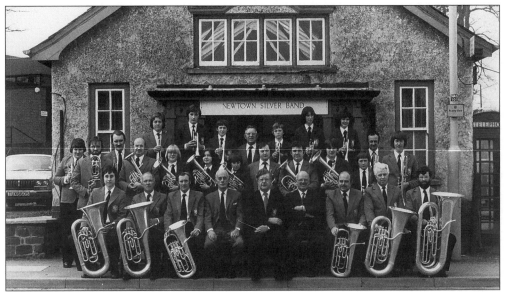

The band outside their band room in Back Lane during their centenary year, 1980. From left to right, back row: D. Morris, C. Jones, P. Morris, E. Goodwin, I. Corfield, H. Evans, N. Vaughan. Middle row: D. Gardner, D. Owen, S. Edwards, F. Shirley, S. Jones, P. Vaughan, T. Evans, A. Breeze, J. Pryce, I. Shirley, P. Jones, P. Evans, P. Lloyd. Front row: S. Lunt, D. Jones, K. Barrett, T.R. Griffiths (president), R. Roberts (conductor), D. Leach (trustee), T. Phillips, J. Bennett, D. Pugh.

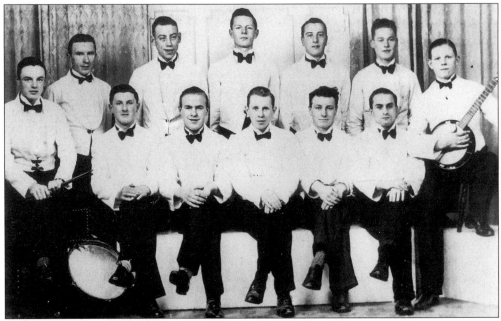

A group that did not last quite so long was the Baptist Minstrel Troupe, seen here in 1935. Nevertheless, two of their members, Bert Hamer and Harry Leach, later became conductors of the Silver Band. From left to right, back row: Evan Morgan, Eric Rowlands, George Davies, George Bevan, Neil Gentle, Bert Bailey; front row: Mervyn Hawkins, Ernie Morgan, Harry Leach, Bert Hamer, Lyndon Boobyer, Leslie Griffiths.

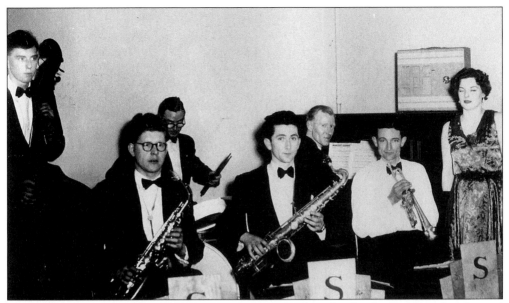

At one time Newtown Silver Band was regularly engaged to play for dances. As styles changed a different sort of ensemble was required. It was not unusual for brass bandsmen to appear in dance bands, although the practice was severely frowned upon in the band room. Members of the Serenaders Dance Band in 1954 were Gordon Woolley (bass), Ron Roberts (sax), Bernard Wilson (drums), Norman Davies (sax), Eric Robinson (piano), Cyril Davies (trumpet), Olwen Davies (singer).

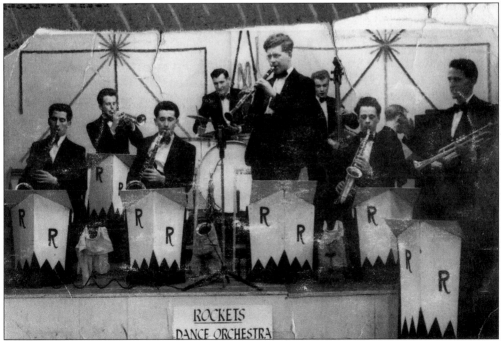

The Serenaders later reformed and became The Rockets Dance Orchestra: Mike Watson (sax), Nolan Bebb (trumpet), Norman Davies (sax), Bob Lewis (drums), Ron Roberts (clarinet), Laurie Hannan (bass), Neville Morris (sax), Eric Robinson (piano), Cyril Davies (trumpet).

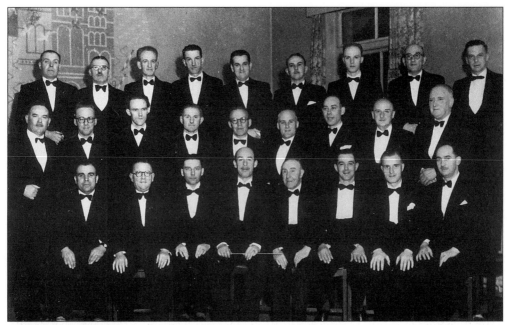

From 1952 to 1966, Newtown Male Voice Choir called themselves The Cedewain Gleemen. Here they are with their conductor Hubert Evans.

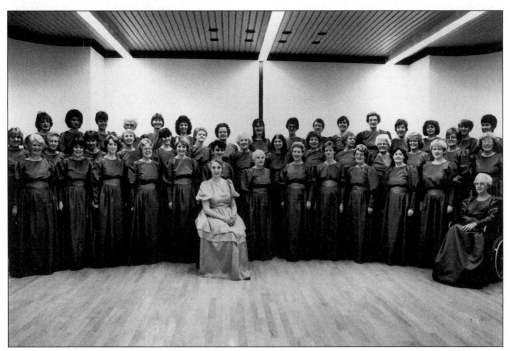

Jayne Davies formed Hafren Ladies Choir in 1968. They won numerous prizes at eisteddfodau and were much in demand for concerts, radio, and television.

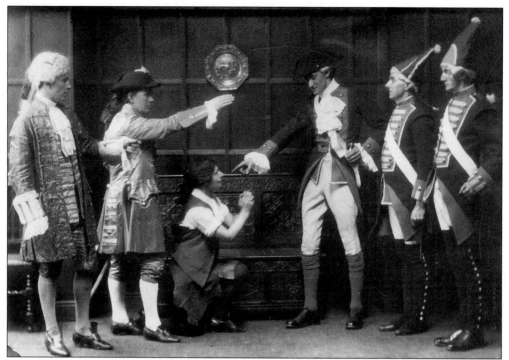

Newtown Amateur Operatic Society was formed in 1931. This is a scene from their first production, *Maritana*.

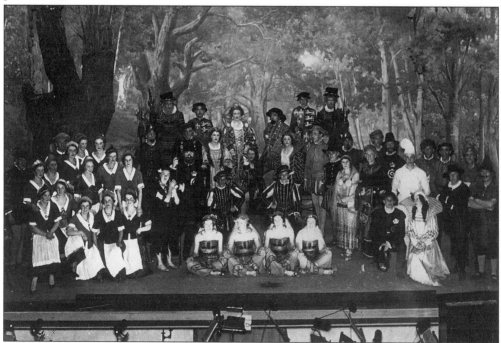

The Operatic Society's last production before the Second World War was *Merrie England*. After the war they reformed with a new production, seen here in 1949 in the Regent Cinema, of *Merrie England*. Note that the cinema had retained its orchestra pit from its days as a theatre.

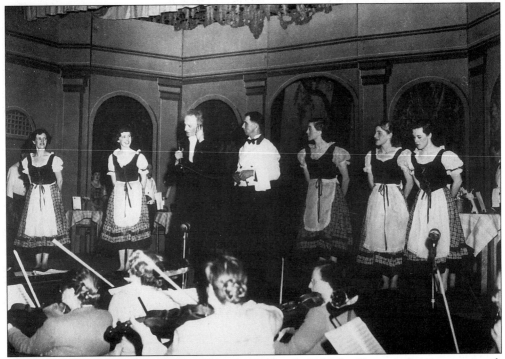

In 1954 the Operatic Society presented *Goodnight Vienna*. The venue this time was the County Pavilion which had been extensively improved two years earlier to enable plays and operas to be performed to audiences of up to 1,200 people.

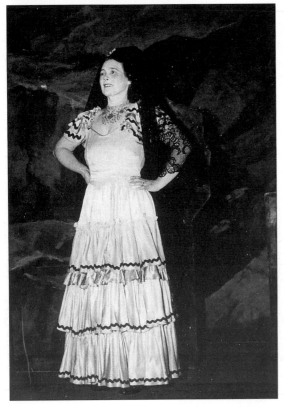

Betty Griffiths as she appeared in *The Desert Song* in 1955. At the age of twelve, Betty was taught to sing *God Be In My Head* by no less a personage than Sir Walford Davies. She has been singing ever since.

Until they created Powys Theatre in Canal Road in 1969, Newtown Amateur Dramatics Society put on their plays in other venues in the town. This 1949 production of *A Soldier For Christmas* was performed in the Church House.

As well as the large-scale productions staged by the operatic and dramatic societies, many of the churches and chapels in the town put on shows. This is the cast of a production by the Methodist Young People's Guild during the Second World War.

The Baptists, too, put on plays. This is the cast of *The Magic Cup* shortly before the Second World War.

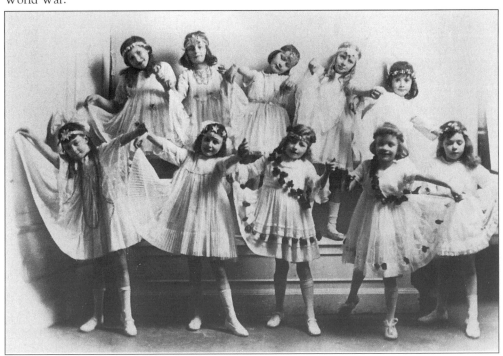

For many years the Misses Macrone, daughters of the St David's Church organist, ran dancing classes for the young girls of the town. This is the class of 1921.

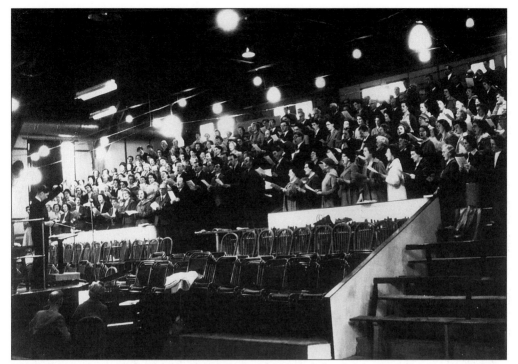

The County Music Festival was inaugurated in 1921 and the County Pavilion was erected to house it. Here in the 1950s Chorus Master Eric Chadwick puts the massed choirs through their paces.

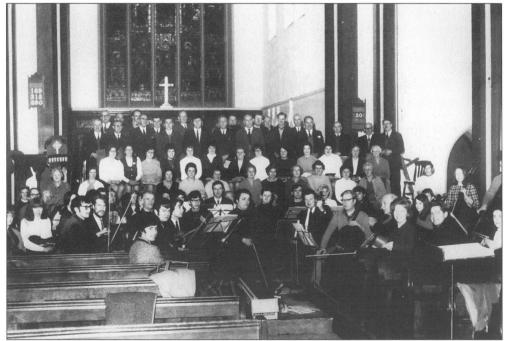

For some years it was the tradition for the town's musical groups to gather in St David's Church for a Festival of Christmas Music. Here they are in December 1969.

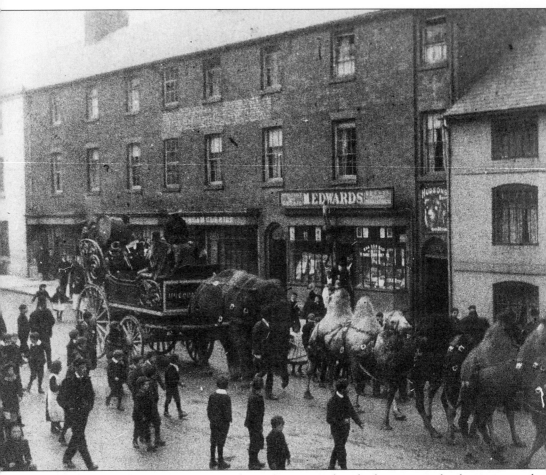

The town's outdoor entertainments have for over a hundred years involved circuses and carnivals. This remarkable photograph, taken in the 1890s, shows a circus parade in Broad Street. Note the band in their magnificent wagon drawn by an elephant.

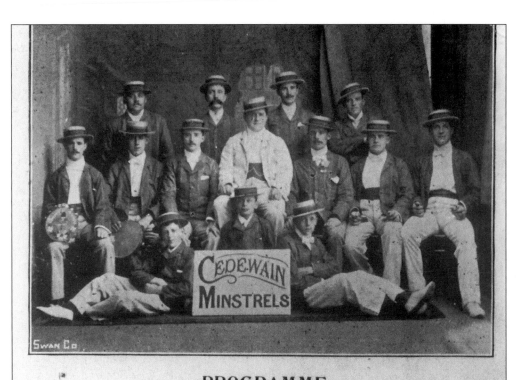

. . . . PROGRAMME

THE SILVER BAND at 6 p.m.

I	MARCH	"The Thunderer"	Sousa
2	SELECTION	"The Toreador"	Caryll
3	WALTZ	"Valse Bleue"	Idryn
4	SONG	"Oh! Dry Those Tears"	Clay
5	GRAND SELECTION ..	'Nadeschda"	Goring Thomas

THE CEDEWAIN MINSTRELS at 7 p.m.

I.—	OPENING CHORUS..	"When the Band begins to play"..	THE TROUPE
2.—	COMIC SONG ..	"I've brought the coal"	DICK THOMAS
3.—	SONG	"Down by the Ferry"	NIXON OLIVER
4.—	COMIC SONG ..	"To-ra-lo-ra-laddy"	F. P. KEAY
5.—	SONG	"True till death"	T. E. JONES
6.—	COMIC SONG.. ..	'Mister Dooley"	JIM OWEN
7.—	SONG	"The dear old home"	WM. PARRY
8.—	COMIC SONG	"Let her drown"	CHARLIE BENBOW
9.—	SONG	'Mary was the Bee"	HARRY MORRIS
10.	COMIC QUINTETTE ..	"Pop goes!" ..	⎧ D. THOMAS, J. OWEN, ⎨ H ROBERTS, F. P. ⎩ KEAY, & C. BENBOW.

THE BAND will play for DANCING at 8 p.m.

Accompanist :—ERNEST OWEN.

Newtown Cycling Club began holding an annual torchlight carnival, probably in the 1890s. This always culminated in a concert in the Public Rooms. In 1903 both Newtown Silver Band and The Cedewain Minstrels were engaged to play as can be seen on this page from the programme. The last Cycling Club Carnival was held in 1909.

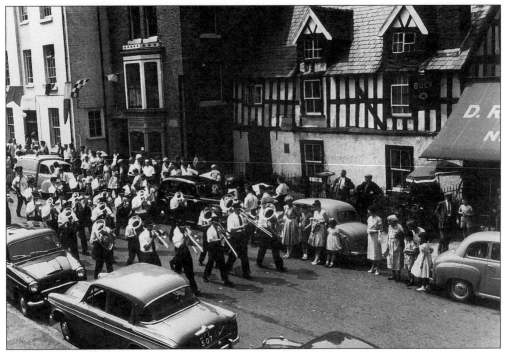

The Carnival procession of 1960. Newtown Band lead off down High Street in shirtsleeve order. The Carnival was revived in 1929 by the Llanllwchaiarn Women's Institute and, apart from the war years, it has been held in June ever since.

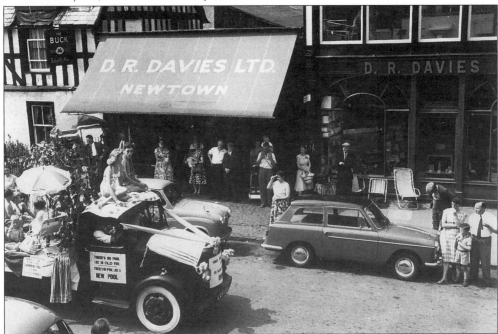

Another part of the 1960 procession. Like many old photographs, the background holds as much interest as the original subject. D.R. Davies's premises were demolished to make way for Boots the chemist.

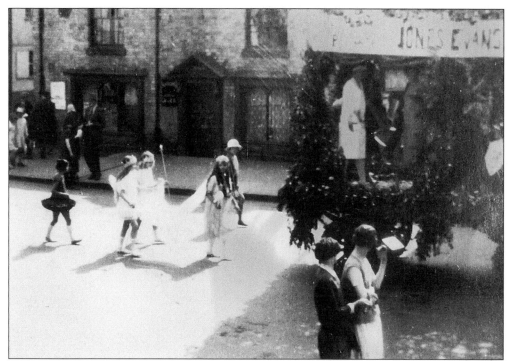

In the first Carnival, Rose Queen Edith Bayley was not the only 'dignitary'. She was followed by twelve-year-old Winnie Bailey as the Queen of the Fairies seen here passing the Blue Bell Inn, which was in Broad Street where Woolworths now stands.

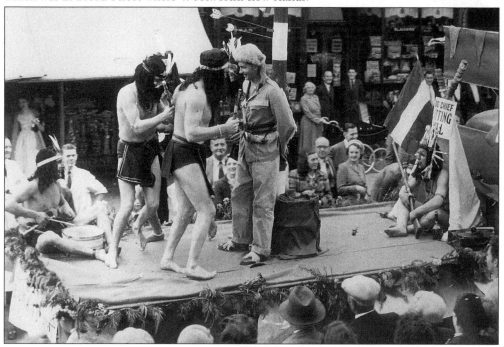

Humorous floats have always been a part of the Carnival. Here, in 1948, Big Chief Sitting Bull's braves do a war dance to the sound of a wind-up gramophone.

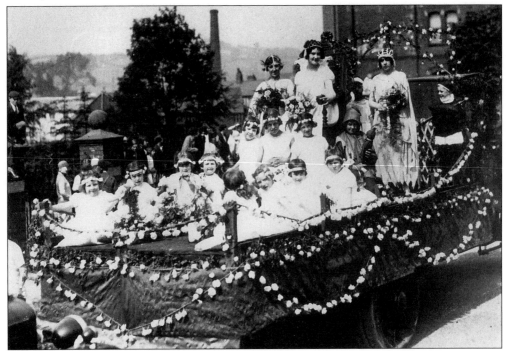

The first Carnival queen was Edith Bayley in 1929. She and her retinue prepare to set off from the railway station on their solid-tyred float.

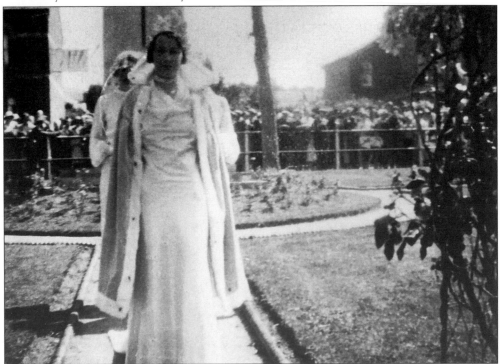

In the early days it was a tradition for the procession to stop at the Cenotaph for the Carnival queen to lay flowers. Edith Bayley returns to her float having laid hers.

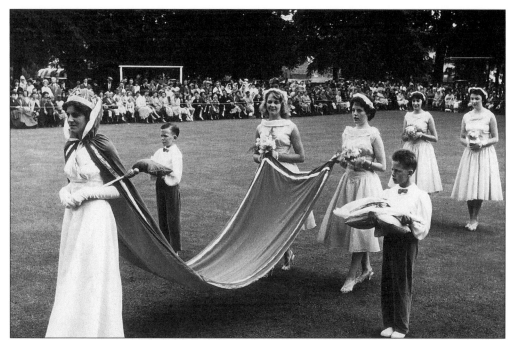

An essential part of the Carnival has been the crowning of the Carnival queen. Queen Ann Davies is escorted in front of a crowd estimated at 4,000 people in 1958. In her retinue were Joyce Bowen, Valerie Crewe, Joan Lewis, and Eileen Stephens. The pageboys were Tommy Morgan and Michael Ray.

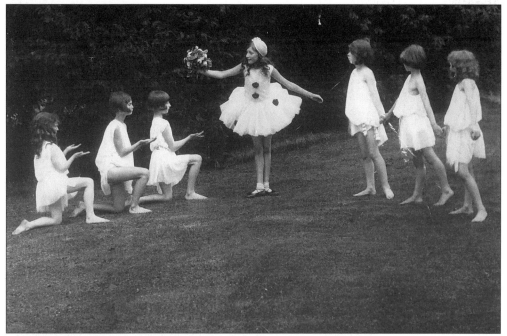

In 1932 the Carnival queen was attended by dancers from Esme Grice's School of Dancing: Gwen Morris, Barbara Pearce, Evelyn Phillips, Noreen Harding, Pam Pearce, Betty Morgan, Betty Daniels.

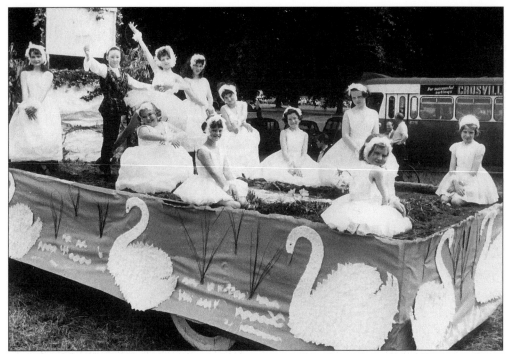

For the young girls of the town 'Swan Lake' is an irresistible theme for a float. These are the St John Nursing Cadets in 1962.

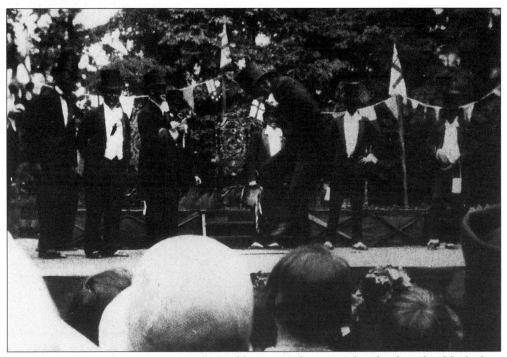

Not all themes used in past carnivals would meet with approval today but this blacked-up minstrel group comes from a different age before the Second World War.

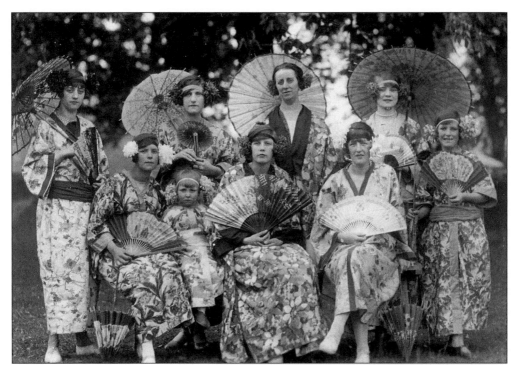

The ladies of Frolic Street and their friends made their own Japanese outfits for a carnival in the 1930s.

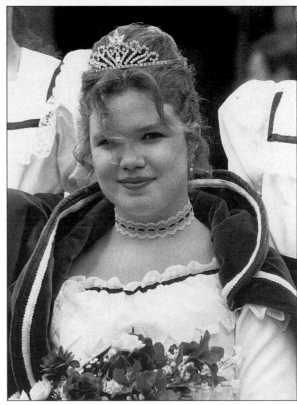

The tradition of having an annual Carnival queen continues. This is Alison Williams, the 1996 queen.

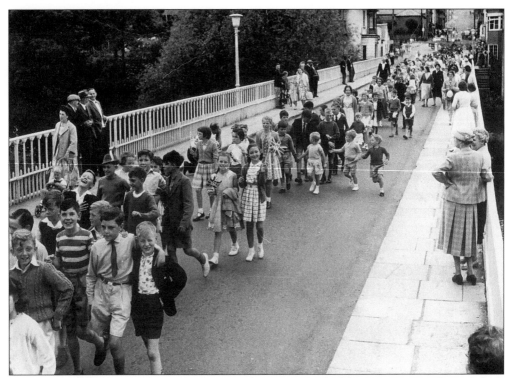

In 1901 Newtown Co-operative Society staged an annual gala (always pronounced 'gay-la'). A procession round the town was followed by sports and other competitions, and a free tea. The galas continued until the local Co-op was taken over by the Co-operative Retail Society in early 1963.

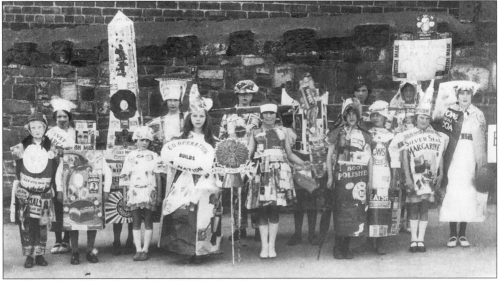

A regular feature of the Gala was the 'making a costume out of posters' competition. The children would collect their old posters from the Co-op in the morning and have their imaginative, if inflammable, outfits ready for the procession in the afternoon. Here are the competitors c. 1930.

Five
Sport

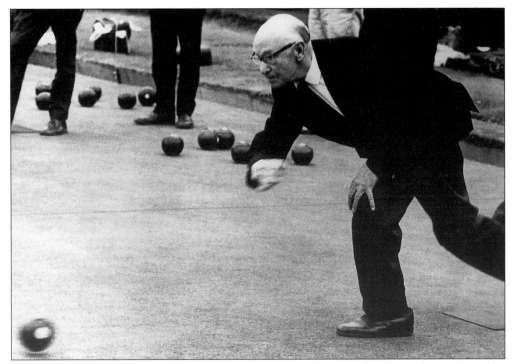

One of the older sporting organisations in the town is Newtown Bowling Club. When they opened their new clubhouse in 1969, Life Vice-President Albert Townsend sent down the first wood.

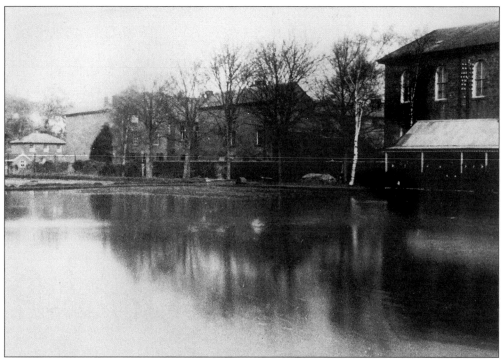

Until the town's flood defences were built in the early 1970s, the bowling green was frequently under water, making it more like Newtown 'Boating' Club!

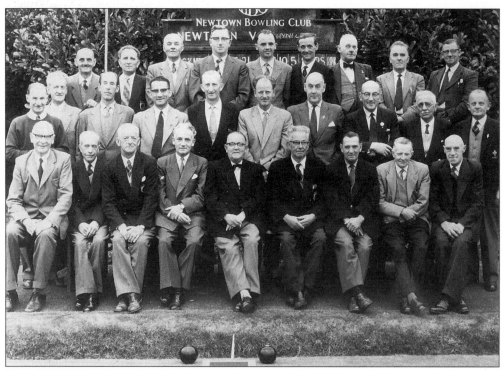

The club members in drier times at about the time of the opening of the new clubhouse in 1969.

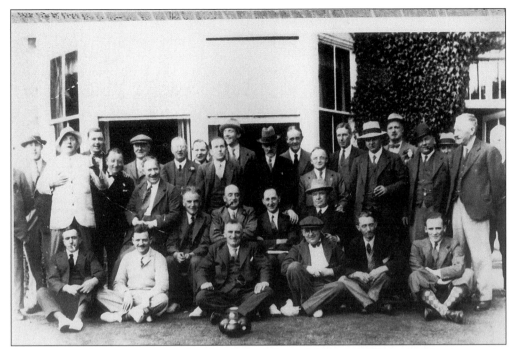

At one time there were two other bowling clubs in Newtown. These gentlemen are the members of the Bear Hotel Bowling Club, formed by the landlord Ivo Smith, on the green that was for many years at the back of the hotel.

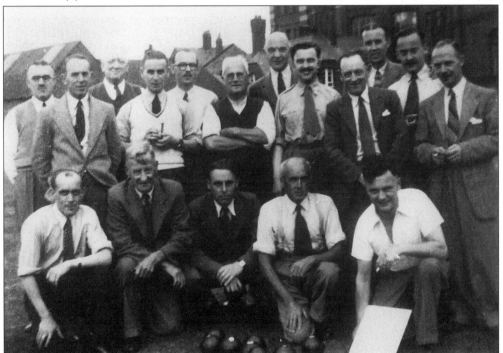

Pryce-Jones's also had a bowling green at the back of their premises where the male members of the staff were able to spend their summer evenings.

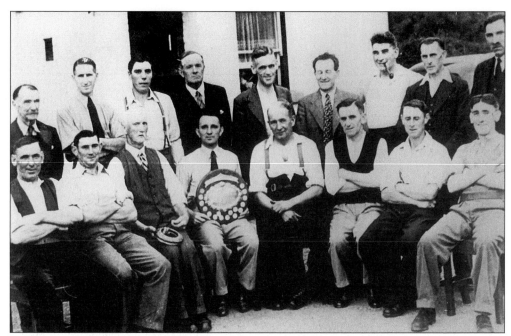

At one time quoits was a popular sport in the area. Here are the Aberbechan and Bettws teams outside the Waggon & Horses on Canal Road, c. 1947. From left to right, back row: W. Potts, Harry Smout, Richard Davies, Richard Gittins, Fred Evans, Albert Weaver, Bert Smout, Arnold Davies, ? Swain. Front row: Charles Davies, Thomas Jarman, Matt Price, Reg Meddins, Tom Bellis, Fred Syers, Sid Jarman, Ll. Williams.

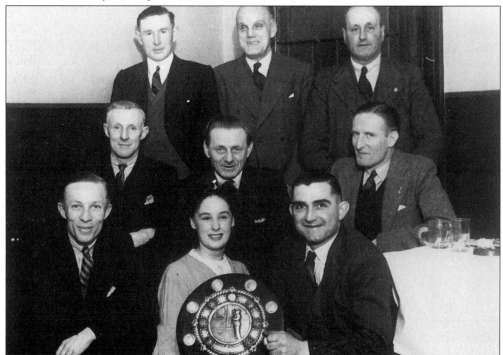

Darts and dominoes remain popular indoor sports. This is the Pheasant Inn team of the 1960s.

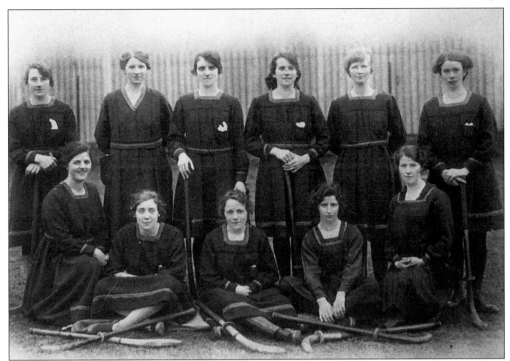

Ladies' hockey also has a long history in the town. This is the team of 1919 which won the first County Shield competition.

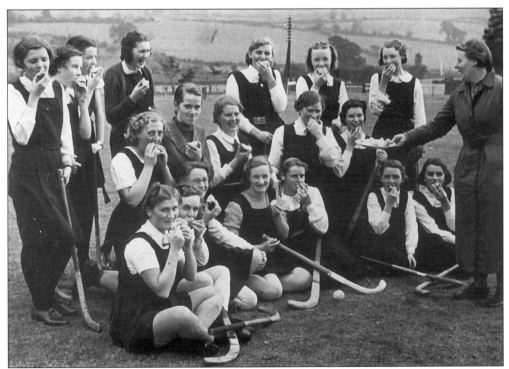

A less formal shot of Newtown ladies' hockey team in 1940.

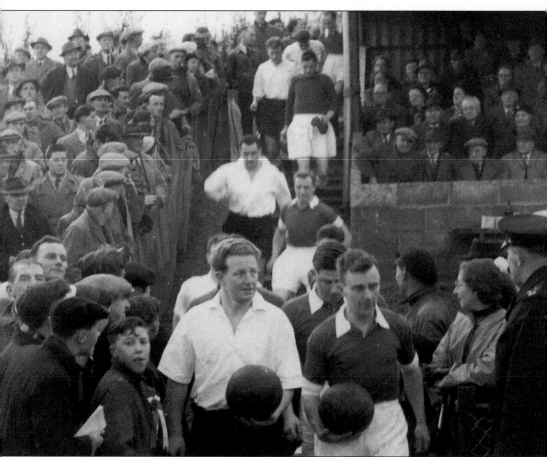

One of Newtown Football Club's greatest moments, even though they lost the match, was when they played Swansea in the Welsh Senior Cup in 1955. Edgar Pugh Williams leads his team onto the pitch alongside Ivor Allchurch of Swansea.

Opposite: Even streets had their teams. These are Park Street Rovers in 1951. From left to right, back row: Keith Bowen, Gwyn Davies, David Jones. Front row: Terry Phillips, J. Williams, Brian Jones, Michael Davies.

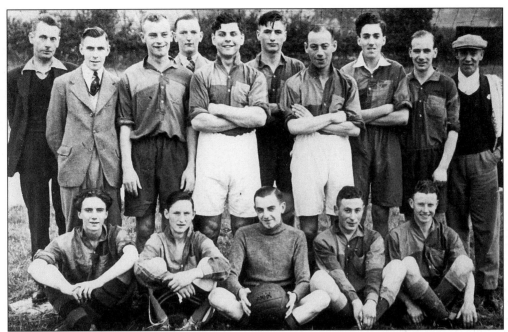

As well as the Newtown FC, there were a number of lesser football teams in the town. This is one of the pre-Second World War 'half-day' teams, which were formed of men who worked in shops and were able to play on Thursday afternoons; Saturday was, of course, a full working day for them. From left to right, back row: George Brown, Sid Colley, Roy Harris, Malcolm Oliver, H. Williams, D. Brown, Eric Rowlands, B. Hill, Les Colley, S. Jones. Front row: T. Morgan, S. Roberts, B. Hedges, Les Ellis, T. Taylor.

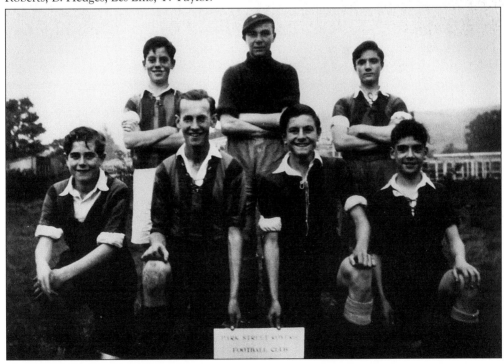

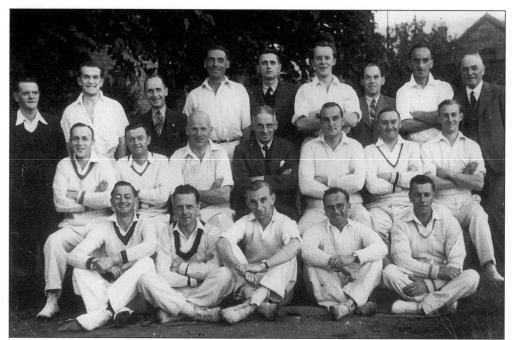

Newtown Cricket Club in 1947. From left to right, back row: Max Owen, Glyn Lumsden, Billy Rees, Walter Lloyd, Hilary Williams, Gordon Lewis, Charlie Bevan, Dennis Powell, George Morris. Middle row: Trevor Jones, Sid Owen, Tom Jones, Wally Morgan, Bert Passant, -?-, Mervyn Powell. Front row: Ianto Rowlands, Cyril Gentle, David Leggatt, Eric Owen.

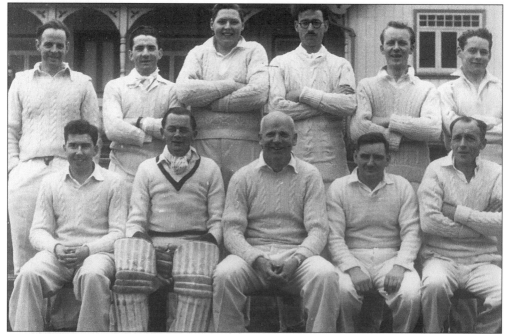

By 1951 the team had undergone a number of changes. From left to right, back row: H. Singleton, Ken Hamer, Bob Kinsey, Ralph Lloyd, Gordon Lewis, Leslie Morris. Front row: Peter Garbett-Edwards, Ianto Rowlands, Tom Jones, I. Walters, Trevor Jones.

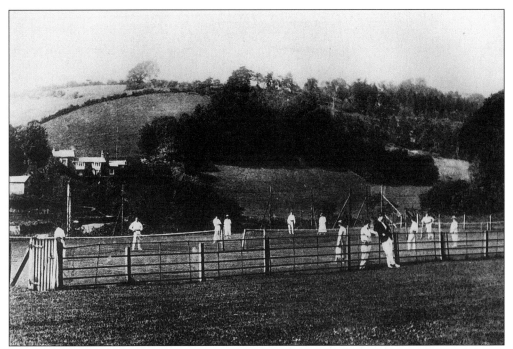

The tennis courts at the Recreation Ground in the 1920s.

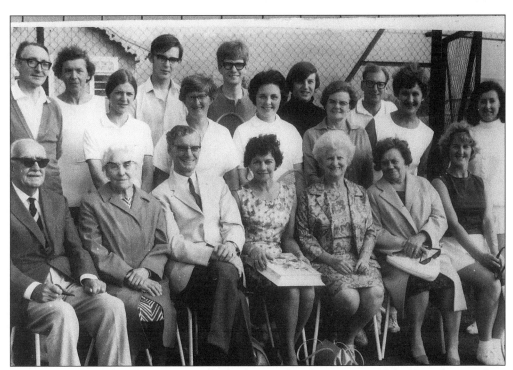

The Recreation Ground courts are still the home of Hafren Tennis Club. Here the members entertain their guests on President's Day in the 1960s.

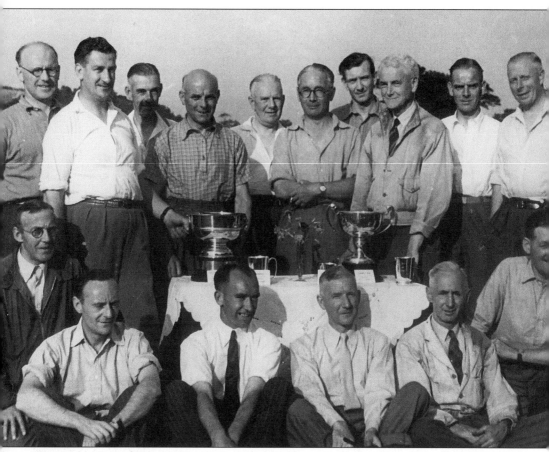

During the Second World War much of the golf course was ploughed up for food production. Soon after full play was resumed, the members gathered around their trophies for this picture.

Six
Then And Now

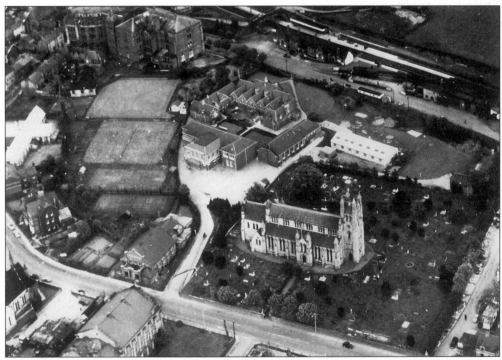

An aerial view of St David's Church and its surroundings in the 1960s; in the top left-hand corner is the Royal Welsh Warehouse. In August 1968 a series of photographs were taken from the RWW roof. In September 1997 the same photographer (with the same camera) returned to the roof and took the same views. The pictures provide a record of how the town has changed in 29 years and the next few pages contain contrasting pairs of these photographs. It is possible only to describe the major changes that have occurred. Close inspection will reveal many, many more.

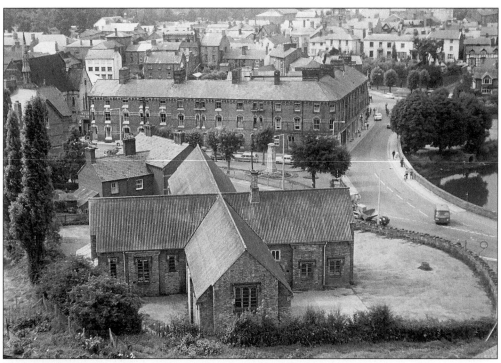

The old Church School has made way for Llys Hafren sheltered housing.

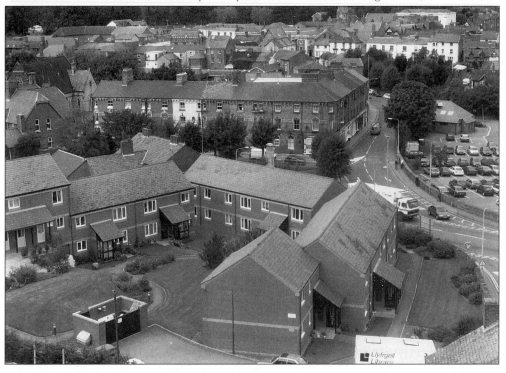

The course of the river was changed as part of the 1970s flood prevention scheme, but the magnificent black poplar tree remains although it is now on the Newtown side of the river rather than the Llanllwchaiarn one! The British black poplar is a rare tree and the nearest similar one is said to be in Somerset.

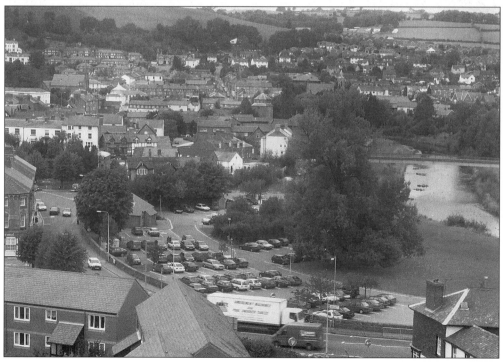

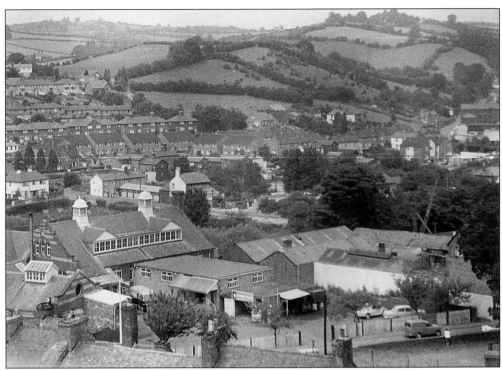

The site that once accommodated the laundry and the Cambrian Foundry now awaits redevelopment.

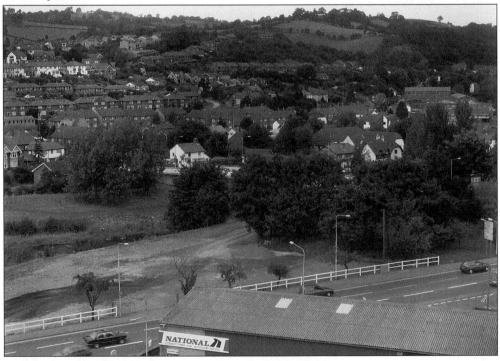

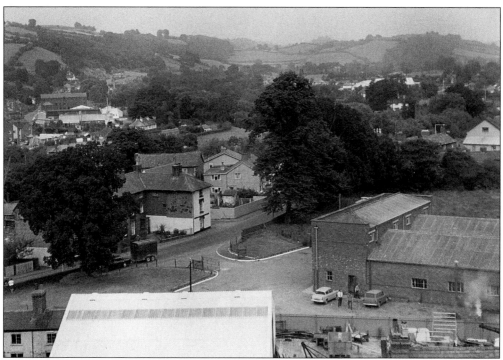

Foundry House and some fine trees have made way for the roundabout giving access to the new Cambrian Bridge.

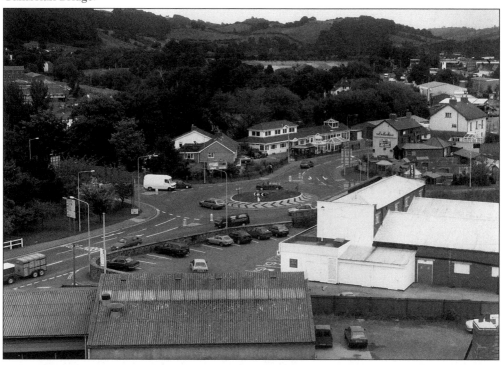

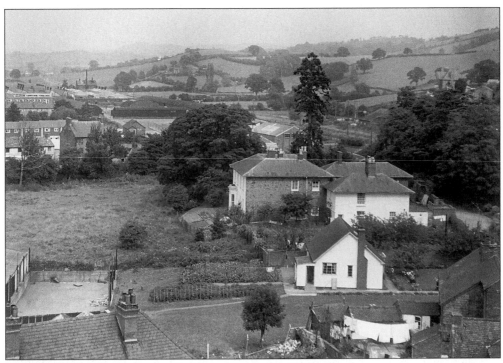

The Rectory Field is now crossed by the new branch of Kerry Road.

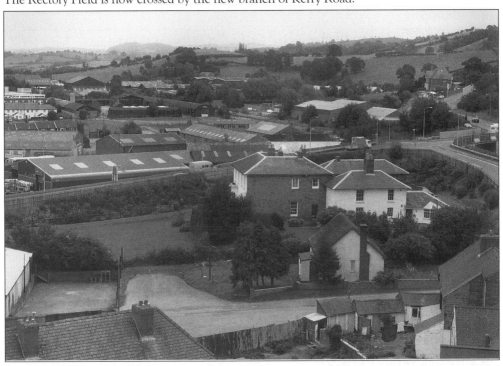

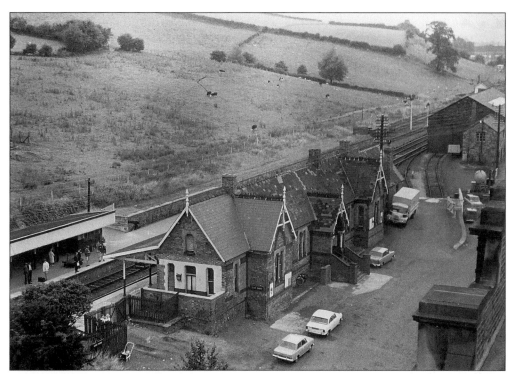

The Newtown station building has changed little, but the cows and the field beyond have made way for Treowen housing estate.

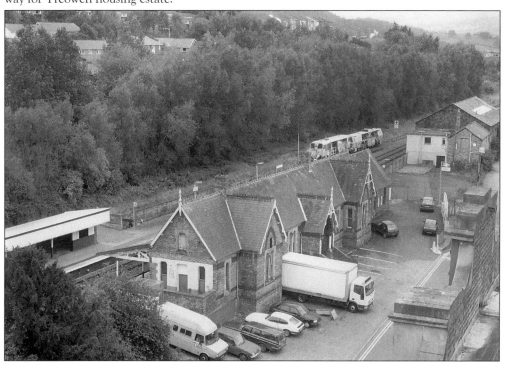

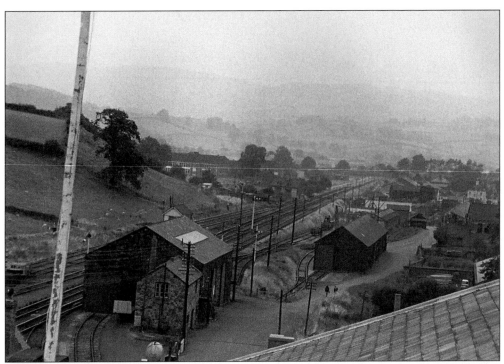

Newtown station no longer handles goods, so the goods yard has gone. The large wooden goods shed burned to the ground in 1989.

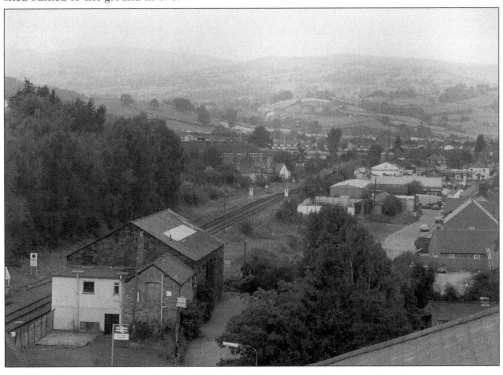

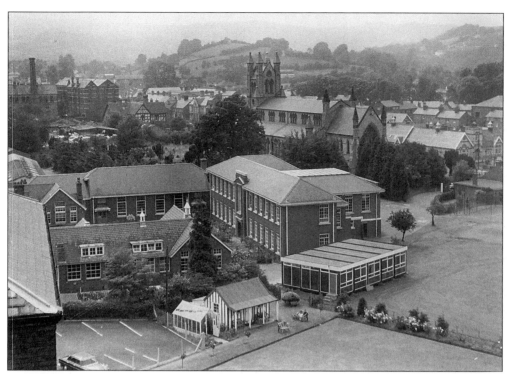

Pryce-Jones's bowling green has made way for a car park and part of the Old College has been replaced by a supermarket.

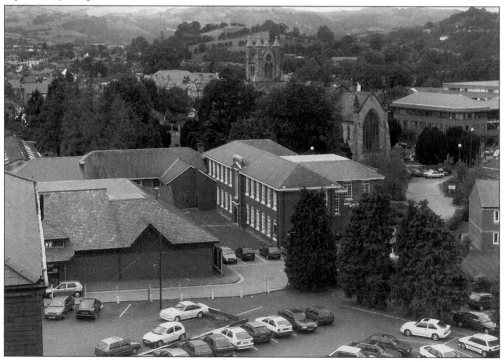

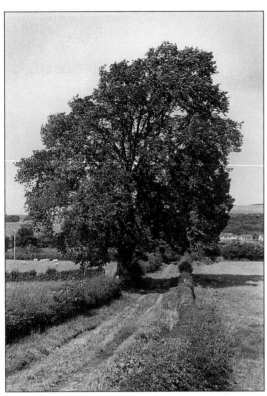

Not all of the town can be seen from Pryce-Jones's, but here are some other 'before and after' pictures also taken in 1969 and 1997 of the junction of Park Lane with Llanidloes Road at Nantoer. A small part of the right-hand hedge remains.

From Park Lane looking towards the town, with Trehafren Hill on the left. The tops of the trees on the hill are still just visible.

The sheep have long gone from Trehafren but the white house on Milford Road can still be seen.

From Park Lane again, looking across the river to the Bryn Wood.

It was not possible to take 'after' versions of the two pictures on this page This one looks across what is now the Mochdre Industrial Estate from Mochdre Lane towards the Kerry Hills and Crow's Lump.

A 'Box Brownie' shot of the 1920s. It was taken from Castell y Dail Lane, looking over Nantoer to Trehafren Hill. The photographer was standing roughly where the electricity pole stands in the above picture.

The fields of Maesyrhandir Farm, *c*. 1960. The farm's orchard is on the right and at the bottom is the railway bridge over the farm lane now known as 'The Tunnel'.

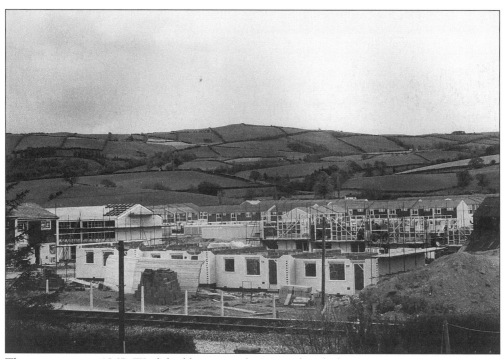

The same view in 1967. Work had begun on the Maesyrhandir housing estate in 1964.

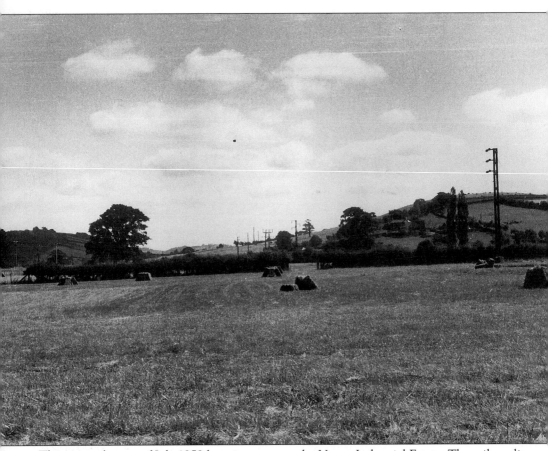

This pastoral scene of July 1959 has given way to the Vastre Industrial Estate. The railway line to Welshpool is on the left and Wern Ddu is in the distance on the right.

Seven
Out Of Town

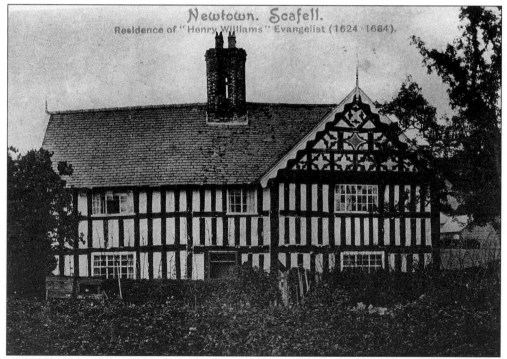

Here, and on the next few pages, are pictures taken in the area around the town. This is the Scafell Farmhouse, about a mile and a half up the Milford Road. Built in the seventeenth century, it was once, as can be seen from the caption, the home of Henry Williams, the famous evangelist.

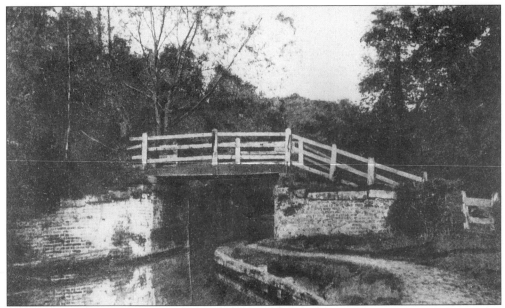

The bridge over the canal at Aberbechan before the navigation fell into disuse in 1936.

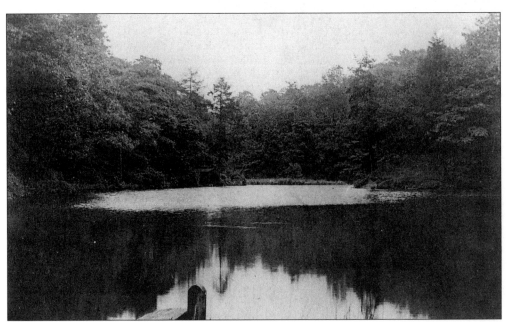

The original caption on this picture is wrong, it claims to be the river at Penarth. The view looks much more like the reservoir at Mochdre, which for many years provided the town's water supply.

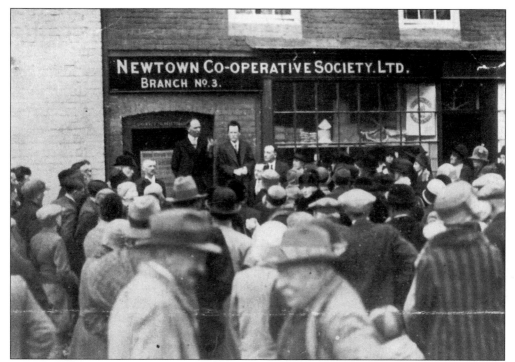

Between the wars Newtown Co-operative Society opened a number of branches in the surrounding towns and villages. This shows the opening ceremony of their third branch, in Montgomery.

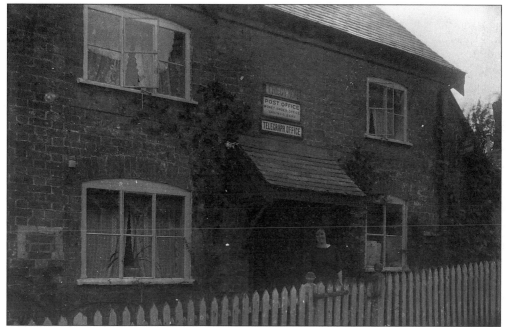

Tregynon post office in the 1920s. This and the pictures on the next three pages were selected from a set of glass-plate negatives all taken in the early 1920s. Some of them have withstood the ravages of time better than others.

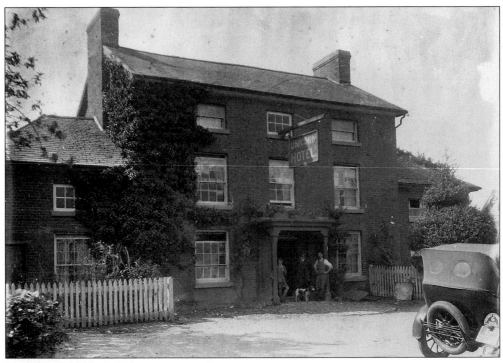

The Unicorn Hotel, Caersws.

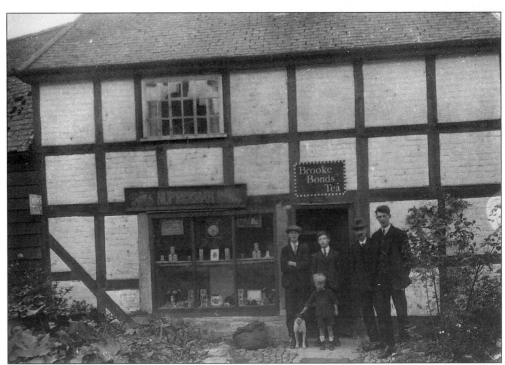

A little way down the road from the Unicorn was Freeman's shop.

In Abermule pub and shop remain in close proximity. On the north side of the road is the Waterloo Arms.

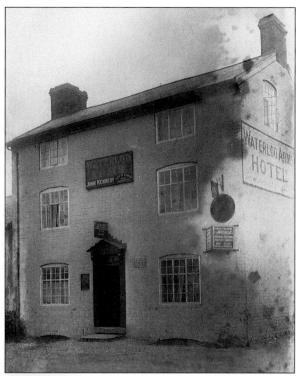

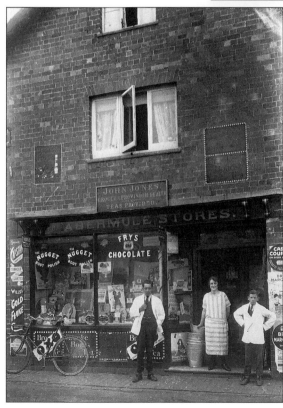

Across the road from the Waterloo is the Abermule Stores.

One of the unusual concrete cottages that stand in Tregynon.

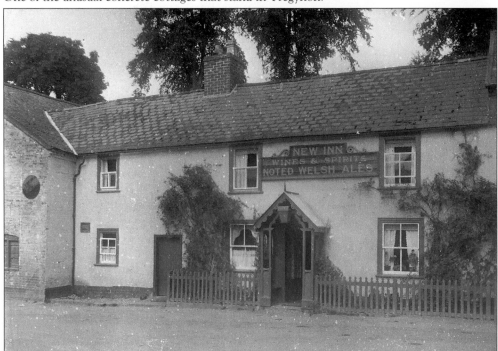

The New Inn in Bettws. It has been substantially modernised since this picture was taken in the 1920s.

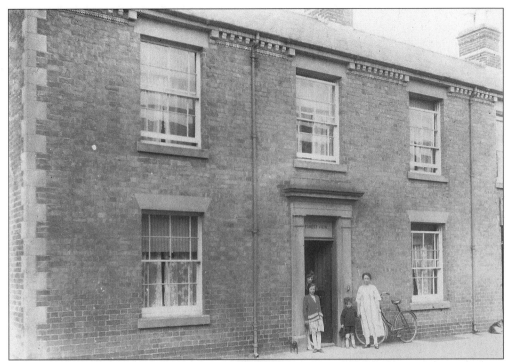

On the main road through Kerry stands this house, Forest View.

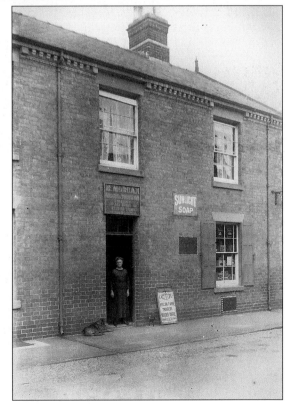

Immediately to the right of Forest View was Morgan's shop. These pictures seem to have been taken on the same day; the dog appears in both.

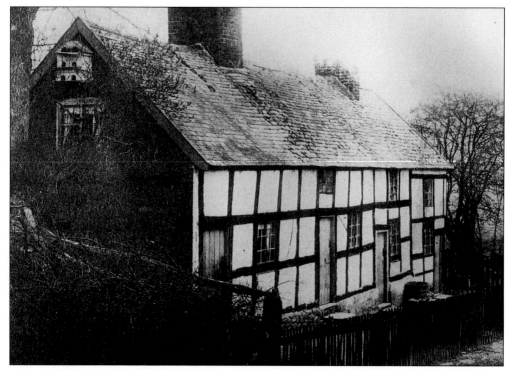

These cottages stood by the road about a mile beyond Llanllwchaiarn Church. For many years they were in ruins but recently they have been re-erected as a single dwelling about fifty yards to the north.

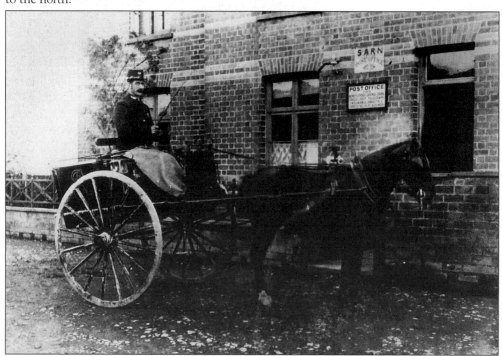

Richard Hamer arriving at Sarn post office with the mail from Newtown in 1905.

Eight
Miscellany

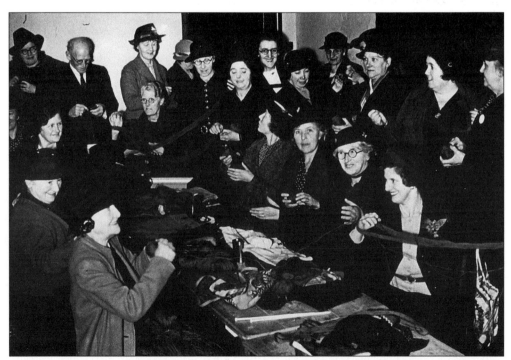

In these last pages are a selection of photographs that would not fit neatly elsewhere but which also record interesting aspects of the town's past. Here, during the Second World War, wool is prepared for knitting socks for soldiers. The solitary gentleman at the back is David Lewis of Baptist Chapel House, who is reputed to have knitted 4,000 pairs of socks during the hostilities.

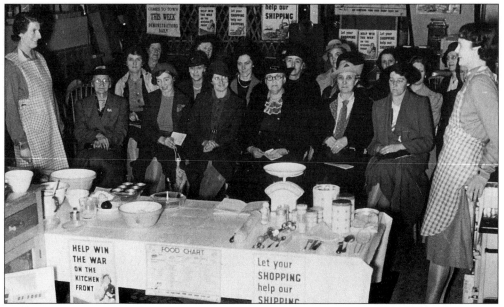

Preparing 'interesting' food, as well as acquiring new clothing, was a problem during the Second World War. Here, ladies of the town get expert advice from a cookery demonstration at D.R. Davies's in High Street.

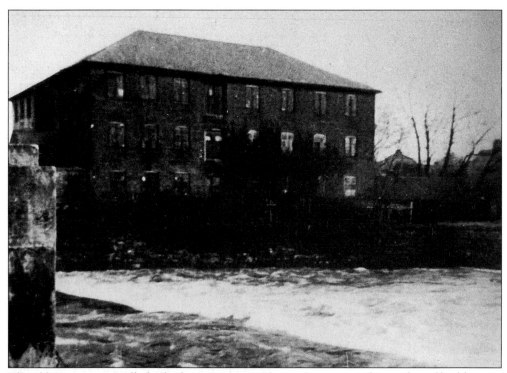

The old Oversevern Mill also had wartime connections. It was one of a number of buildings in the town used by the Admiralty for storing the Royal Navy's supply of rum. It burned down in December 1944.

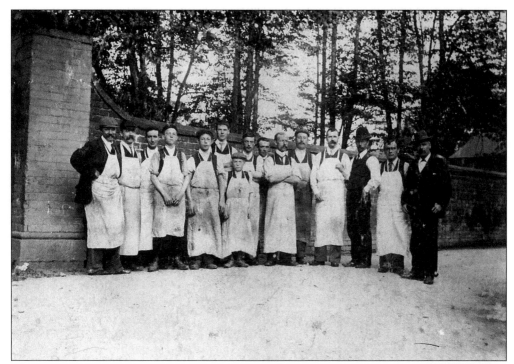

The printers of the *Montgomeryshire Express* by the wall of the Old Church, *c.* 1910. The printing works was across the road in Old Church Place. Sixth from the right is the foreman printer, David Jabez Jones, whose son Ronald and grandson Elwyn became the proprietors of the Severn Press off Severn Square.

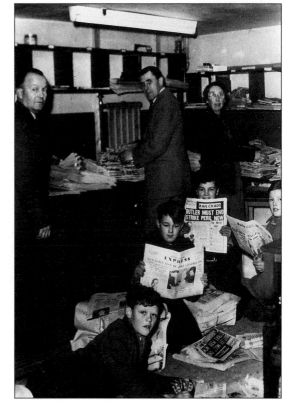

Early morning at Griffiths & Griffiths, the newsagent's in Broad Street in 1960. Trefor Hughes, Sid Colley, and Phyllis Davies sort the papers before delivery by the paperboys.

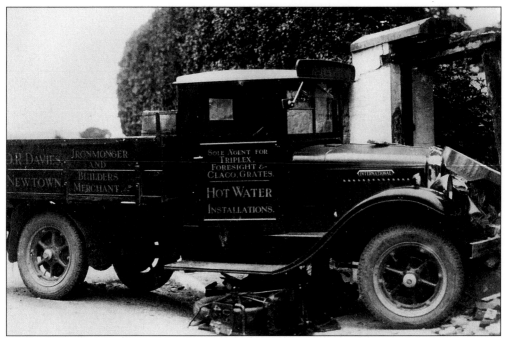

In the early 1920s D.R. Davies's delivery lorry came to grief having first hit a motorcycle and then the wall of Plas Cae Crwn. Remarkably, the motorcyclist was unhurt.

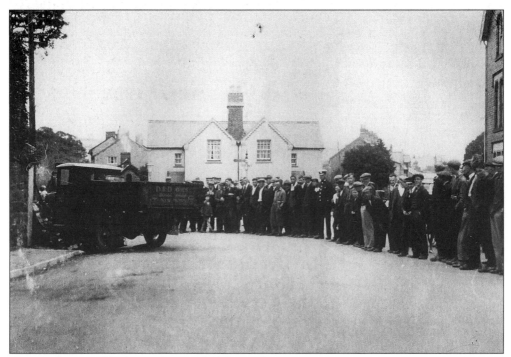

The accident quickly drew a (very orderly) crowd.

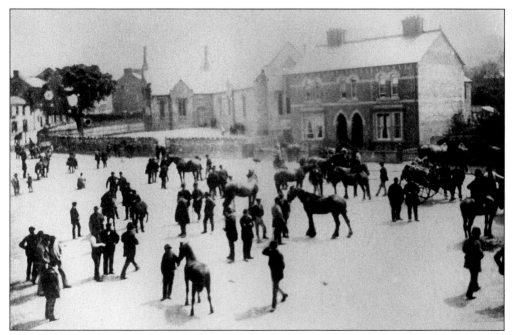

When New Road was developed in the 1860s, the horse market moved from Market Street and Short Bridge Street. This piece of land, seen here in the 1890s, was given to the town in 1870 by Richard Long of Kerry. By the turn of the century it had been fenced in to become Clifton Park.

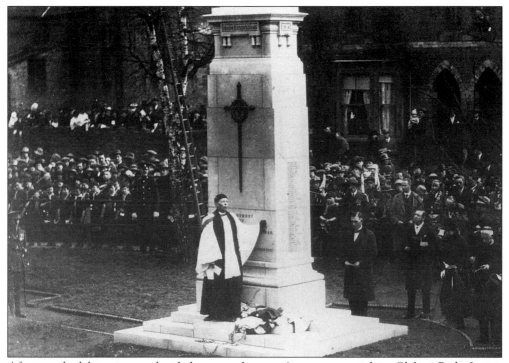

After much debate it was decided to put the town's war memorial in Clifton Park. It was dedicated, as seen here, on 18 January 1925.

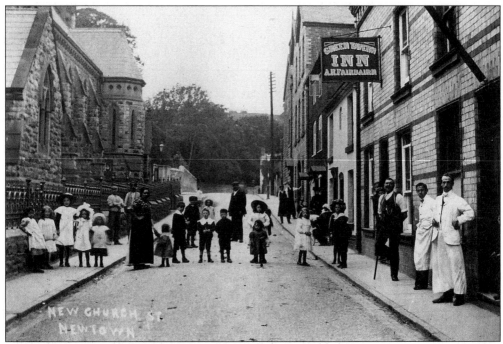

New Church Street still leads from the junction with Back Lane to New Road although it has changed almost beyond recognition. These two views were taken *c.* 1900 from opposite what is now the entrance to Ladywell House. All that remains in this view looking north is the Congregational Church on the left.

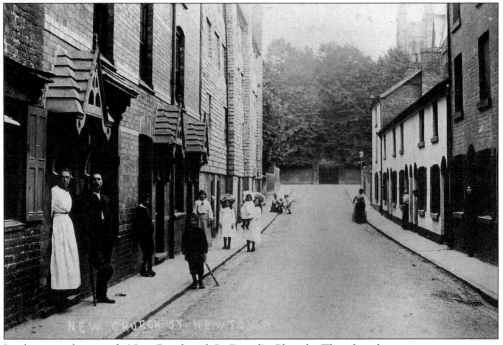

Looking south towards New Road and St David's Church. The church gates remain as seen here.

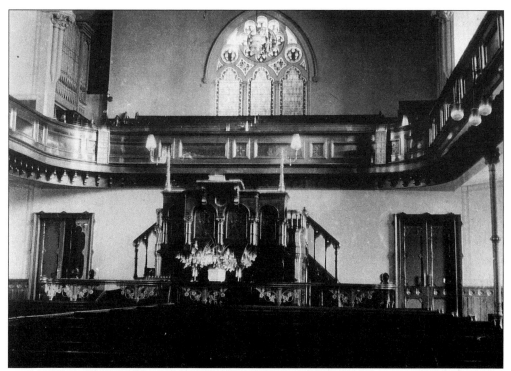

The interior of the old Wesleyan Methodist Church in what is now part of Back Lane. The church was demolished and replaced by the present building in 1983.

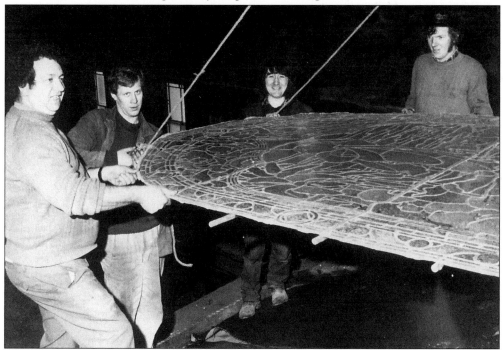

Great care was taken in removing the windows of the old church and some of them were incorporated in the new one.

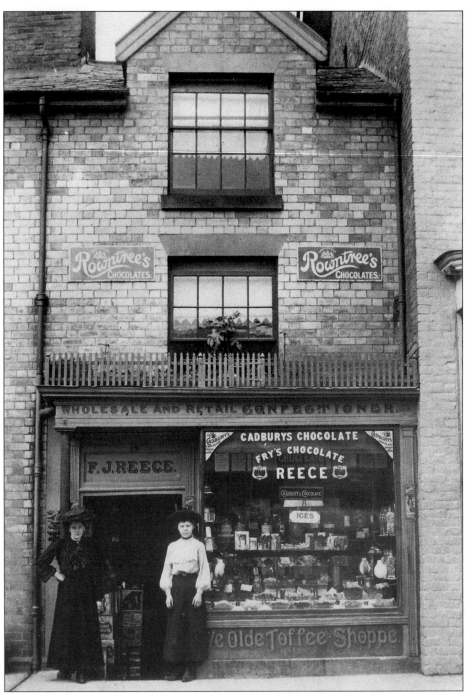

Before the turn of the century William Hibbott had a sweet factory in Weir Street. His wife ran this shop, selling the sweets, in Broad Street. After William died, his widow continued running the shop. Eventually, she remarried and ran the business under her second husband's name, Fred J. Reece. Mrs Reece was later widowed a second time, and eventually gave up the business in 1908. The shop was demolished in 1935 to make way for Woolworths. Just visible on the right of the picture is part of what became Lloyd & Lloyd's ironmonger's shop.

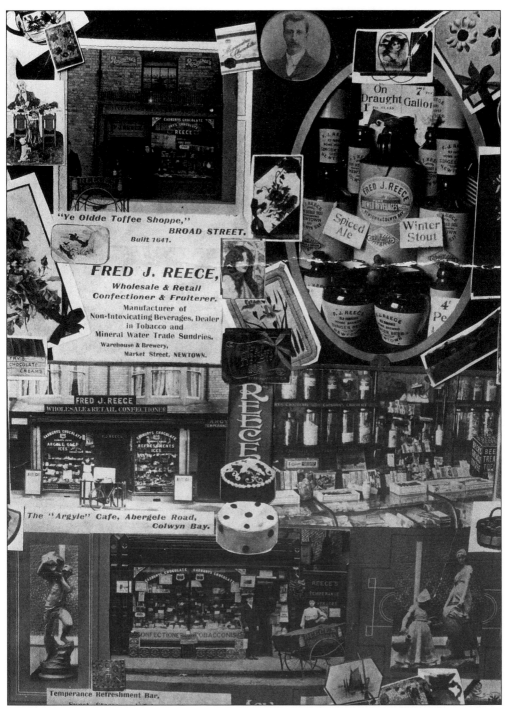

Mrs Reece was a remarkable woman. At one time, as well as bringing up children by both husbands, she was running the three shops depicted in this advertising collage. At the top is another view of the Broad Street shop. In the middle is the Argyle Café in Colwyn Bay and at the bottom is a second Newtown shop in Market Street. This shop later became Payne's and is now Beta Fruit.

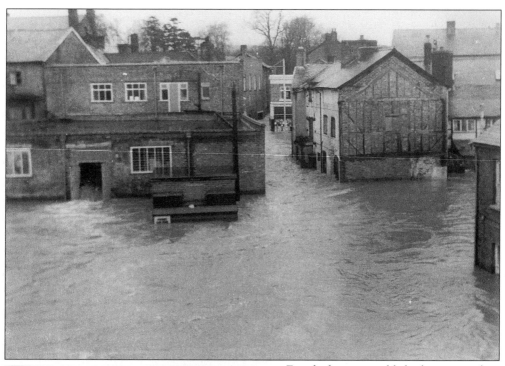

Four hitherto unpublished pictures of
the 1964 flood in Old Church Street.
Woolworths in Broad Street can just be
seen between the back of the Spar and
the buildings opposite.

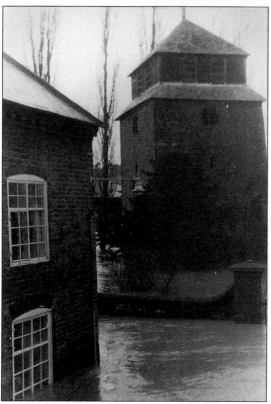

It was events like this that led the
Rectors of Newtown to move to the new
Rectory (*see page 86*) in 1813. The old
Rectory is on the left. The parishioners
of St Mary's followed to higher ground
when St David's Church was
consecrated in 1847.

The floods did serious damage to many buildings in the town but remarkably all the ones seen here survived, albeit in need of extensive repairs.

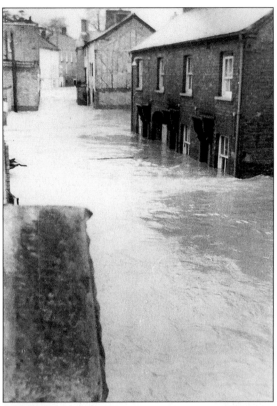

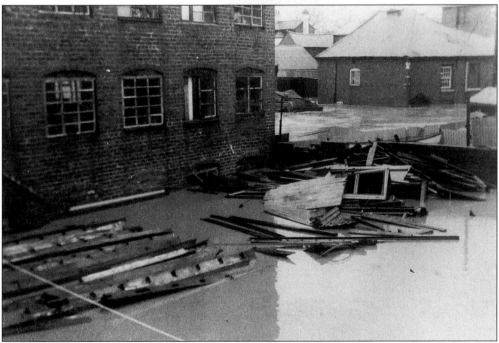

On the other hand, all the buildings which comprised Old Church Place and Skinner Street went and were replaced by St Mary's Close. Golwgydre can just be seen in the distance.

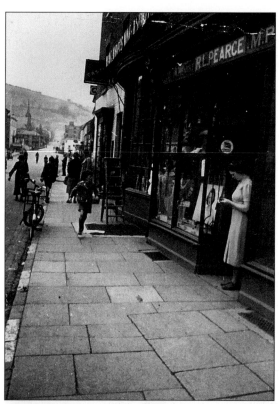

An informal view of the east side of Broad Street. Pearce's Chemists is now the Home Improvement Centre.

All these houses in Turner's Lane have gone. Part of what was the Music Salon can be seen in Broad Street.

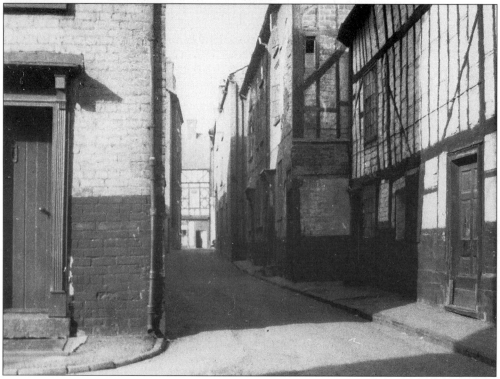

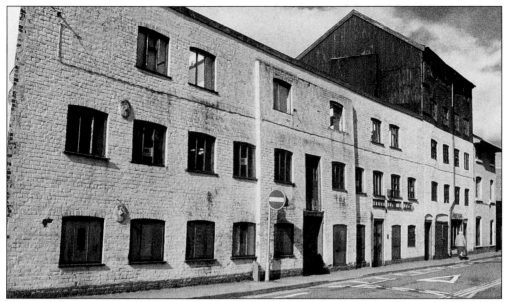

This building, once six storeys high, was originally the Quill Factory, possibly the first hand-loom factory in the town. The top storeys were removed in 1956 by which time it had become Herron's Furniture Warehouse. All the buildings seen here were demolished in 1990 and the land on which they had stood remained undeveloped and became known as 'The Galliers Site'.

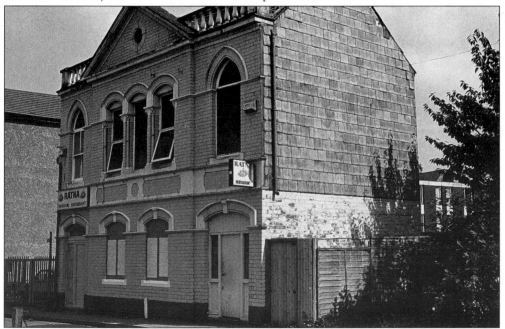

This building, opposite the Quill Factory, was built to house the Local Board, which was established under the Local Government Act of 1858. The Board was replaced in 1895 by the Urban District Council, which occupied the building until it moved to Newtown Hall in 1947. The Council Chamber was upstairs, while downstairs was the surveyor's office and the town's mortuary. After the UDC moved, the building became first a church and then an Indian restaurant. It was demolished to make way for Bear Lanes.

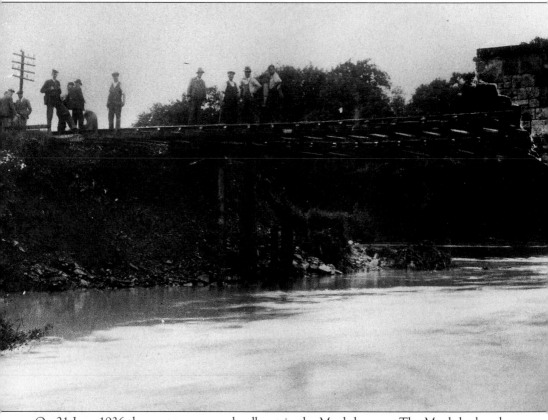

On 21 June 1936 there was a severe cloudburst in the Mochdre area. The Mochdre brook rose rapidly and soon became a torrent rushing down to meet the Severn at Dulas. Eddie Haynes, a railway worker, and his daughter Bernice, walked down the line from their home at Scafell Halt to Dulas Bridge which carried the Newtown to Caersws tracks over the brook. They watched the raging waters swirl beneath the bridge. The flood was bringing a great deal of debris with it and to their horror the father and daughter saw, in the water, a huge tree rushing like a battering ram towards the bridge. The outcome was never in doubt. The entire bridge was carried away although the tracks remained slung across the chasm. As a railwayman, Eddie knew that a train was due to leave Caersws for Newtown shortly. Urgent action was called for. Fortunately, as a County hockey player (she is among the group at the bottom of page 75), Bernice was a good runner. She turned and ran two miles along the line to Newtown signal box. She was in time. The signalman was able to telegraph Caersws and the train was held. Now a great-grandmother, Mrs Bernice Roberts still remembers the day when she was able to prevent a dreadful disaster.